Art Classics

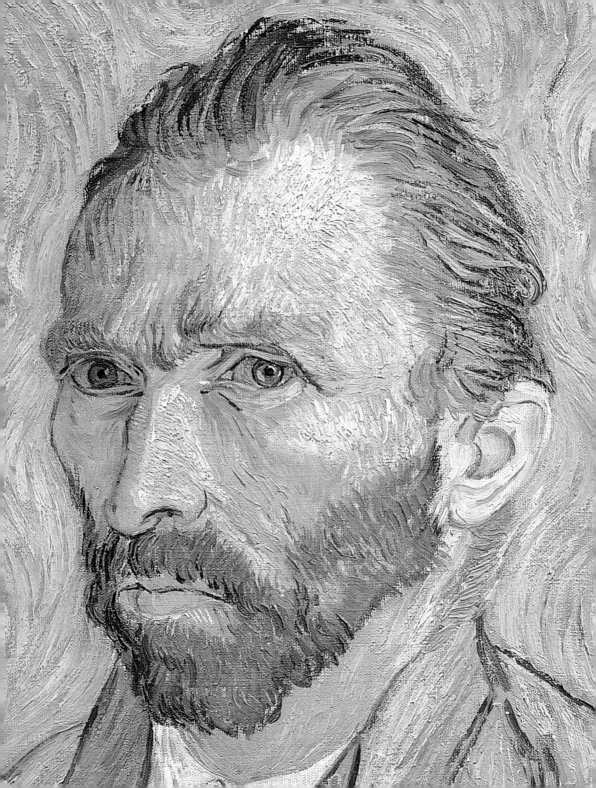

Art Classics

VAN GOGH

Preface by Giulio Carlo Argan

RIZZOLI
NEW YORK

ART CLASSICS

VAN GOGH

First published in the United States
of America in 2005 by
Rizzoli International Publications, Inc.
300 Park Avenue South
New York, NY 10010
www.rizzoliusa.com

Originally published in Italian by
Rizzoli Libri Illustrati
© 2004 RCS Libri Spa, Milano
All rights reserved
www.rcslibri.it
First edition 2003
Rizzoli \ Skira – Corriere della Sera

2005 2006 2007 2008 2009 /
10 9 8 7 6 5 4 3 2 1

Printed in China

ISBN: 0-8478-2729-1

Library of Congress Control
Number: 2005921998

Director of the series
Eileen Romano

Design
Marcello Francone

Translation
Timothy Stroud
(Buysschaert&Malerba)

Editing and layout
Buysschaert&Malerba, Milan

Cover
Twelve Sunflowers in a Vase
(detail), 1888
Munich, Neue Pinakothek

Frontispiece
Self-portrait
(detail), 1889
Paris, Musée d'Orsay

The publication of works owned by
the Soprintendenze has been made
possible by the Ministry for Cultural
Goods and Activities.

© Foto Archivio Scala, Firenze, 2003

Contents

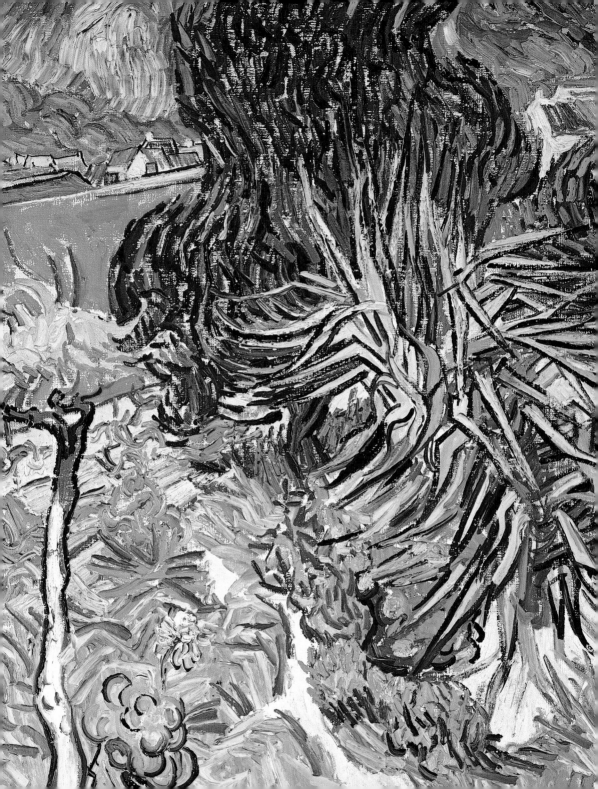

Art and the Absurd
Giulio Carlo Argan

T he archetype of the artist who feels excluded from a society that does not appreciate his work and which turns him into a misfit and a candidate for madness and suicide began with Van Gogh. But it is not only artists at risk: a pragmatic society that considers work to exist purely for reasons of profit cannot but reject anyone who reflects on the condition and destiny of humanity and exposes its bad conscience.

The place of Van Gogh is alongside those of Kierkegaard and Dostoevsky; like them, he pondered in anguish the meaning of existence and the purpose of his life. He felt himself to be one of the disinherited and the victims: like the exploited factory workers or rural laborers from whom industry, by offering land and bread, removes their ethical nature and conscientious attitude toward work. Van Gogh was not a painter by vocation but desperation. He had tried to become a member of society but had been rejected; he had given himself to the church and become a missionary among the miners in the Borinage in Belgium, but the official church sided with the owners and expelled him. At the age of thirty he rebelled and his rebellion took the form of painting: it repaid him with asylum and suicide.

Allowing himself to be inspired by Daumier and Millet, early on in Holland Van Gogh examined the country's social problems and darkly illustrated the misery and desperation of the peasant laborers. His paintings were dark and almost monochrome and the figures he portrayed were deliberately made ugly. The industrial development taking place in the cities had left the countryside a place of suffering, depriving it not just of the joy of life but of light and color, so Vincent decided to leave for Paris, where in 1875 he had once worked in the print shop of Goupil & Cie. He arrived for his second visit in 1886, saw the work

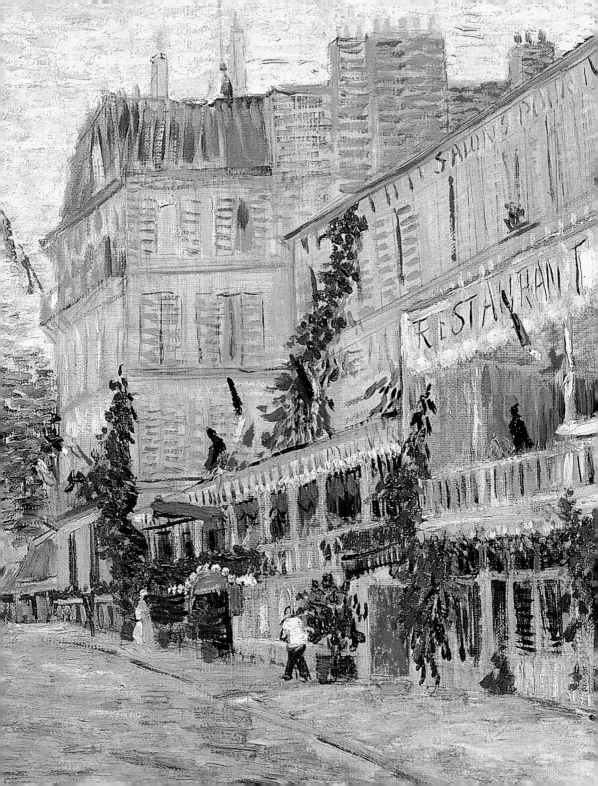

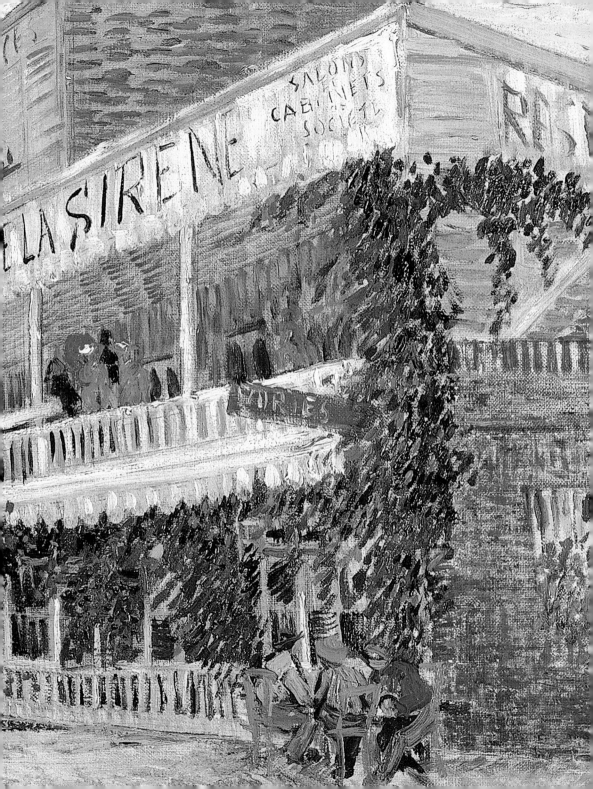

of the impressionists and became a friend of Toulouse-Lautrec. He abandoned the depiction of social themes and moved on from his variations in black and brown to a violent use of color. He moved to Arles in 1888 and in just two years completed his work as an artist. His dream had been to create with Gauguin (who prudently backed out) a "school of the south" that would renew the fundamentals of art by taking the premises of impressionism as far as they could go. Why did he abandon the social debate at the moment in which his moral commitment was at its most decisive and aggressive? His contact with the advanced French art movements had convinced him that art should not be a tool but an agent of transformation for society and, at an even more basic level, of one's experience in the world. He believed that art should be an active force, a glaringly clear truth used to counteract the growing tendency toward alienation and mystification. He was also convinced that the technique of painting had to develop in order to oppose the mechanical technique that symbolized industrial mass production and to arouse the deep forces of existence: it had to represent the ethical nature of man against the mechanical nature of the machine. There was no longer any question of depicting the world either superficially or profoundly: every mark that Van Gogh made on the canvas was used by the artist to confront reality and to claim for his own his essential being, his life—a life that middle-class society, with its alienating concept of work, extinguishes in man.

Impressionism had made great strides but it was not enough just to receive unadulterated sensations from reality as one does not live by sensations. After 1880 the impressionists themselves felt the need for greater depth and, more than the others, Cézanne devoted himself to investigating the structure of sensation, aiming to prove with facts that sensations are not the raw material of consciousness but that it is consciousness that forms the basis of existence. Van Gogh did not follow Seurat and Signac in an attempt to found a new science of perception based on the genuineness of sensation, nor did he try to go beyond the physical nature of a view and investigate the spirituality of vision. He countered cognitive experimentation and total classicism with his own ethical research and intense romanticism, thus, whereas the painting of Cézanne lies at the root of cubism in its

attempt to create a new perceptive structure, the painting of Van Gogh underlies expressionism in its proposal of art as action. The question that bothered Van Gogh was how can reality be perceived? Not by one who tries to know it through contemplation, but by one who exists within it, who feels it as a limit upon himself and from which he cannot free himself unless by grasping it, making it his own and identifying it with that "passion of life" of which in the end we all die. Not an impression, sensation, emotion, vision or the intellect, but the pure and simple perception of reality here and now. He believed that it is only by becoming aware of the limit and forcing it that one is able to burst through it. What Van Gogh wanted was a true form of painting that extended as far as the absurd and which remained valid even as far as paroxysm, delirium, and death.

How did he deal with reality? He painted a portrait of a postman, Monsieur Roulin. We know he is a postman by his dark blue, gold-trimmed uniform and the block capitals on his cap. The dominant touch of color in the painting is the yellowish gold trim that stands out against the blue cloth. There is no social slant in the portrait; it does not show M. Roulin because he is a postman, nor because he interests the painter as a man. It is simply a fact that M. Roulin is a postman, that he wears that uniform and that he has a stubbly beard that contrasts with his pinkish flesh and blue eyes. The painting neither judges nor comments: the painter can only experience the reality passively or make it his own—or *remake* it with the paint and skills that are his as a painter and part of his existence. What he does is to build and model the reality he sees using color: he *experiences* the thickness of the cloth in the opaque density of the blue, the bristly roughness of the beard in dry, hard brushstrokes, and the transparency of the flesh in the cold veils of pink. He does not digress to describe the setting: the background is a plain painted wall, of the wicker chair we see only the arms and the seat, of the table only the corner on which the postman's arm rests. Why is the table greenish and not the color of wood? Why are the edges outlined in blue? Green (yellow + blue) is the dominant color in the painting; the edges are blue like the tunic: the figure is outlined in the same way but, instead of bringing the postman into contact with the surrounding space, the blue outlines isolate him

In Front of the Asylum at Saint-Rémy (detail), 1889 Private collection

and help to make him a reality that must be confronted, one that cannot be removed. Anticipating existentialist thought, Van Gogh seems to have believed that reality (whether in the form of M. Roulin, the café in Arles, wheat fields, or sunflowers) is *other* than himself, but that without that *other* he would not be aware of himself, indeed he would not be. The more *the other* is *other*, different and non-communicating, the more *I am I*, the more I discover my own identity, the sense-no-sense of my existence in the world, and the more the world manifests its discontinuity and fragmentariness to our daunted awareness.

From the above it is clear that Van Gogh learned all there was to be learned on the reciprocal influence of colors from the impressionists, but these relationships did not interest him for their visual associations; their appeal lay in their relationships of strength (attraction, tension, or repulsion) within the painting. As a result of these relationships and contrasts the image tends to be deformed and lacerated through the strident combination of colors, the broken outlines and the rapid rhythm of the brushwork that turn the painting into a series of feverishly animated, quivering symbols. The impasto acquires its own, extreme, almost intolerable existence: the painting does not offer a representation, it simply is. Where is the "tragic" element in the portrait of Postman Roulin? It is not in the figure, who poses tranquilly, without drama, nor is it in the colors, which are dazzling and almost joyous. The tragedy lies in seeing the reality and seeing oneself in it clearly and peremptorily. It is tragic to recognize that our own limits lie in the limits of things and to know that we cannot free ourselves of them. It is tragic, when faced by reality, not to be able to contemplate that reality but to have to take action, with passion and fury, to prevent the existence of reality from overcoming and destroying our own. Art then becomes (as the poet Cesare Pavese would have said) the "task of living." It was this task of living that Van Gogh so desperately embraced to counter the mechanical nature of the work proposed by industry, which represents not living. Therefore Van Gogh's initial artistic discourse was not abandoned but taken to a deeper level, where not only the content, subject and thesis were at stake but the very substance and existence of art.

14

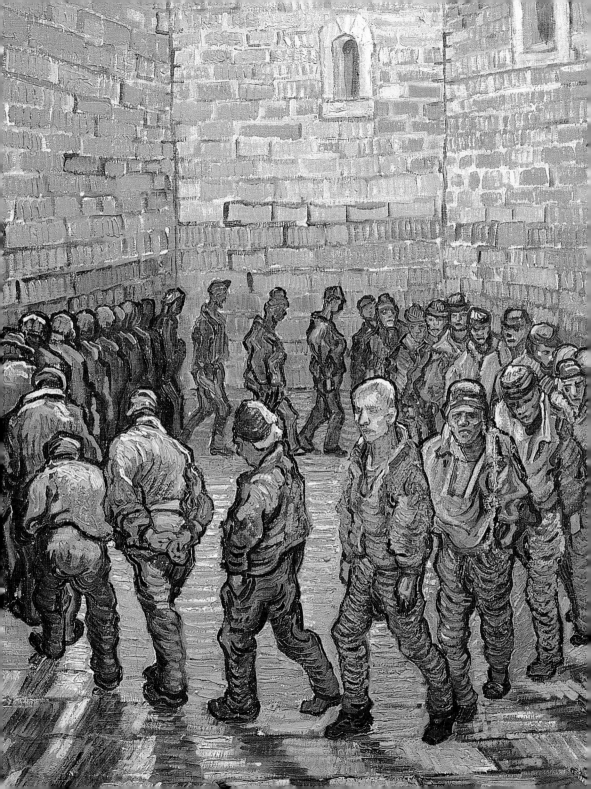

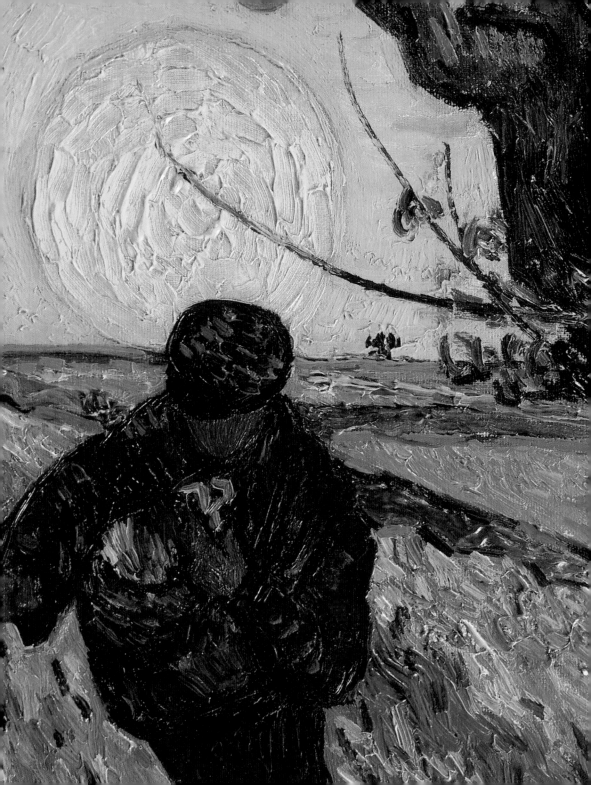

His Life and Art

Vincent van Gogh is undoubtedly one of the world's best known artists. His unique and moving painting style is recognizable even to those who have no experience of art. His troubled life and tragic suicide have made him an icon of modernity and a symbol of the existential torment that has afflicted society since the end of the Industrial Revolution brought an accelerating rhythm to life and the growing alienation of the individual. The "myth" of Van Gogh has also been nourished by literature and cinema: in 1921 the German writer and art critic Julius Meier-Graefe published Vincent: *Der Roman eines Gottsuchers* (published under the English title, *Vincent Van Gogh: A Biographical Study*, 1926), followed in 1934 by *Lust for Life* by Irving Stone. Stone's book inspired the famous 1956 film of the same name directed by Vincent Minnelli starring Kirk Douglas as Vincent and Anthony Quinn as Gauguin. Psychoanalysis has always found artists a fertile source of study—for example, Freud wrote on Leonardo and Luca Signorelli—and in 1922 Karl Jaspers "diagnosed" Vincent's illness as schizophrenia. In fact it is more probable that the artist suffered from epileptic attacks aggravated by the instability of a roving life and an unusual sensitivity.

The fictional works based on the life of Van Gogh have undoubtedly been aided by the enormous number of letters he wrote, which have provided invaluable information on his artistic theories, his character, and the events of his life. From 1872 the artist carried on a continual and busy correspondence with his brother Theo, a dealer in avant-garde art who was one of the first to champion the impressionists. At the end of the nineteenth century communications were only possible by letter so that we should not be surprised either at the existence or the quantity of these letters. What is unusual is that they have been kept: it was practically the norm to destroy the correspondence of artists on their death to preserve their privacy. It was Theo's wife (Theo only

survived his brother's death by six months) who not only preserved them, though she destroyed many of her husband's letters, but also published them in their entirety together with many to Wil, the sister of the two brothers, and to several friends and colleagues.

Recognition of Van Gogh—which only began to come into existence during the last months of his life—has been furthered by the many large exhibitions of his works held since the 1980s and the astonishing prices individual paintings have reached at auction over the last twenty years.

The image that has grown up around Van Gogh is one of an outsider, one that led to the prototype of the misunderstood genius, the mad but intuitive artist whose paintings were ahead of their time. Certainly it is not easy to categorize his work stylistically, even during a period that, in every branch of art and culture was noted for being the epoch of *–isms*: a period of continual proliferation of movements, from impressionism to symbolism, and from decadentism to futurism.

In the 1830s, a group of painters who were to become famous as the "Barbizon School" revolutionized French landscape painting by going to work at the village of Barbizon in Fontainebleau forest not far from Paris. Following the example of the innovative landscapes painted by Jean-Baptiste Corot and the English artist John Constable, who sketched directly from nature, Théodore Rousseau, Charles-François Daubigny, Jules Dupré, and others began to paint *en plein air* (outdoors) thus achieving a more natural vision and representing ephemeral scenes and variable lighting effects. Nor were they the only ones to move away from the academic conventions, as the second half of the nineteenth century was dominated by realism, with its social themes, "democratic" scenes, and indifference to the formal criteria established by the painting of the past, which were replaced by the introduction of "ugly reality" as a new aesthetic category. Courbet concentrated prevalently on the plight of the indus-

trial working class whereas Jean-François Millet, who often went to paint with the Barbizon artists, gave his attention to peasant laborers. In the 1860s, under the star of Édouard Manet, a group of youngsters, whose interests in painting the truth were not all alike, brought impressionism into being. Claude Monet, Auguste Renoir, Edgar Degas, Camille Pissarro, Alfred Sisley and, initially, Paul Cézanne shared an interest in modern life, a new freedom in composition, and a more liberal painting technique that allowed them to render the luminosity of colors and depict the changeability of the weather and the instantaneousness of perception.

In 1886, when Van Gogh moved to his brother's house in Paris, four large exhibitions offered a panorama of the artistic trends in the world capital of art: one displayed the works of Puvis de Chavannnes at the Salon, whose scenes, inspired by the art of ancient Greece, seemed to have no physical or temporal context and were to have a powerful influence on the nascent symbolism; another was the eighth impressionist show, by which time only some of the founders of the movement still exhibited together; in this exhibition a painting by the young Georges Seurat created a sensation: *A Sunday on La Grande Jatte – 1884*. The painting had been created by the application of tiny dots of pure color set close to one another (from which followed the label pointillism) so that the colors were not mixed on the palette by the painter but occurred in the perception of the observer, thereby creating an effect of increased luminosity. Seurat, who had painted the work in his studio from a series of preliminary studies made from nature, had been inspired by the treatise written by Michel-Eugène Chevreul on the *law of simultaneous contrast of colors* (1839) and studies by Charles Henri on the scientific basis of aesthetics. The impressionist exhibition also contained landscapes by Gauguin and a series of nudes by Degas but the founders of impressionism, Monet and Renoir, had decided to exhibit their works in the upmarket gallery of Georges Petit. The final exhibition in the

capital at that time was at the Salon des Indépendants, where Seurat once again presented his *Grande Jatte* with other "impressionist dissidents" such as Paul Signac, Camille Pissarro, and his son Lucien. These "Neoimpressionists" were supported by the critic Félix Fénéon who argued how "naturalistic" impressionism had been supplanted by "scientific" impressionism.

Van Gogh completed his early learning period in the midst of a great ferment of styles and trends, but, though he was interested in the more progressive artistic movements of the time, he was not a member of the impressionists, nor the pointillists, nor can he be considered a symbolist to all intents and purposes. He brushed against and took inspiration from each of these currents but formulated a very personal style that remained his alone.

The son of a Protestant minister and the eldest of six children, Vincent Willen van Gogh was born on March 30, 1853 in the village of Groot Zundert in

northern Brabant. When he finished school in 1869 he went to The Hague where he became an apprentice at the Dutch branch of the Parisian art dealer's Goupil & Cie following a recommendation by his uncle Vincent (who was to be become one of the most important art dealers in Europe). Goupil dealt particularly in nineteenth-century French and Dutch paintings and reproductions. Van Gogh was thus able to familiarize himself with the scenes of peasant life by Millet, one of Europe's most admired artists, and with those by the Barbizon school. Like the tradition of Dutch painting in the seventeenth century, the Barbizon school inspired a "School of The Hague" which included Jozef Israëls, Anton Mauve, and Jacob Maris. They focused on peasant life, the countryside and the sea and rendered their paintings with delicate gradations of gray. In 1873 Vincent transferred to Goupil's London branch while Theo, his younger brother by four years, was hired in Brussels by the company at the start of a long career. Theo was a shrewd and innovative dealer who

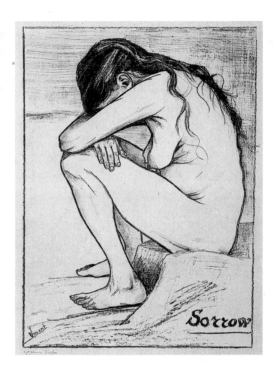

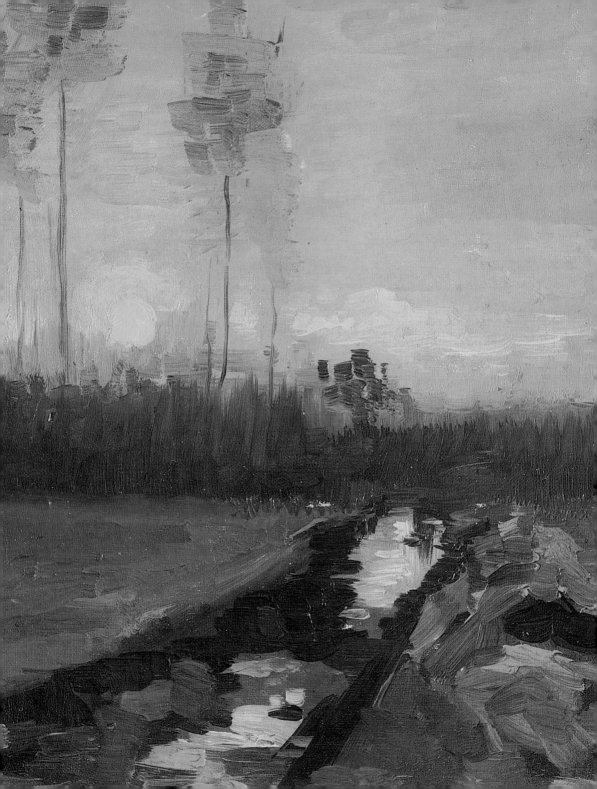

constantly championed younger painters and supported the impressionists when they were considered as not much more than daubers. Vincent, on the other hand, had no interest in the art market and his growing impatience, despite a further transfer to Paris, led him to resign in 1876. This act, however, was not an attitude adopted by a "pure" artist toward the market as in this period Vincent had not yet started painting and his gesture was rather dictated by his intention to become a preacher. He went back to England where he initially found employment as a teacher in a private school and then became the assistant to a Methodist minister named Jones who allowed Vincent the opportunity to give his first sermon. The text, which has survived, was erudite and inspired: Van Gogh described life in the world as the route followed by a pilgrim and even described a painting to make his simile clearer. When he returned to Holland to spend Christmas with his parents (who had moved to Etten near Breda), he allowed himself to be convinced by his family, who were worried by his physical and psychological state, to remain in the country. He moved to Amsterdam to study for the entrance exam for the Department of Theology, began to translate the Bible into four languages and studied ceaselessly the functions of various religious confessions. Another activity was his increasingly frequent visits to museums (he was particularly fascinated by Rembrandt), where he assiduously began to teach himself to draw. He wrote to Theo in 1878, "I should like to begin making rough sketches from some of the many things that I meet on my way, but as it would probably keep me from my real work, it is better not to begin" (letter to Theo 126, November 15, 1878).

Vincent was so sure of his wanting to devote himself to preaching to the poor that he gave up his idea of studying theology and registered in the more practical Preparatory School for Evangelists in Laeken. Although he was the best-prepared student in the class, he was not considered suitable for the scholastic exams, above all due to his "lack of

submission." Showing stubborn will, which was a characteristic of every aspect of his life, and having succeeded in getting himself a six-month appointment from the Evangelist School in Brussels, in 1879 he went to the Borinage, a mining region in Belgium where the workers lived in miserable conditions. He was certainly influenced by idealism and suffused by the Christian humanitarianism championed by his father, but due to an excessive zeal that bordered on fanaticism he lived in a hut, slept on the floor, fasted, gave away all his goods, looked after the sick, and preached in the mine his appointment was not renewed. Nonetheless, he did not give up and continued his work as an apostolate without pay in spite of this crushing disappointment.

In the meantime he dedicated himself to reading, including Shakespeare, Aeschylus, Charles Dickens and Victor Hugo, and to drawing the miners "till late into the night." He became increasingly enthused by art and in 1880, caught up obsessively once again, he set out to walk the seventy kilometers to Courrières to meet the painter Jules Breton, one of the Barbizon landscape artists. When he reached the house he felt upset at its "inhospitable, stone-cold and forbidding aspect" (letter to Theo 136, September 24, 1880) and could not pluck up the courage to meet the artist he admired so much.

This was the time that Theo began to send his brother money, something that gradually became Vincent's only source of income, but it was also the moment that the elder brother made his decision to become a painter himself. In truth painting had never ceased to interest him and no letter exists in which it is not mentioned or in which Vincent did not ask his brother for news or information. That happened even at the height of his religious commitment, to the extent that the two topics were often combined seamlessly: "The other day I made a little drawing after Émile Breton's "A Sunday Morning," in pen and ink and pencil. How I like his work! Has he made anything new this year? Do you see much of

his work? Yesterday and today I wrote a composition on the parable of the mustard seed and it is 27 pages long; I hope there is some good in it." At the end of the letter he added, "tell me something about the painters whenever you hear something interesting about one of them" (letter to Theo 124, early August, 1878).

Although he had been drawing for some time, Van Gogh had never received any specific training. He had used a self-teaching manual—the *Cours de dessin* (*Drawing Course*) by Charles Bargue, published by Goupil—which contained illustrations of plaster models and works by great masters to be copied. In 1880 he asked his former principal, Tersteeg, to send him the *Exercises de fusain* (*Charcoal-Drawing Exercises*) by the same author and Theo to send him some prints, beginning with the series *Work in the fields* by his beloved Millet. In the same way that he had dedicated all his efforts to apostolic work, now he devoted himself to art. He moved to Brussels "as I feel that it is absolutely necessary to have

good things to look at, and to see artists work." He thought of studying at the Académie des Beaux-Arts and began a series of anatomical drawings. He also began to collect prints, with particular interest in the work of Millet, Daubigny (another Barbizon painter), the realist Daumier, who was one of the best exponents of social painting in spite of his brilliant satirical impulse, and the great engraver Gustave Doré.

In April 1881 he returned to Etten where he remained for several months drawing landscapes and rural laborers. At the end of the year he began to take lessons from Anton Mauve, his cousin by marriage and an outstanding member of the School of The Hague. It was under Mauve's supervision that Van Gogh produced his first oil paintings. Following a bitter argument with his father, he moved to The Hague where he spent a lot of time with Mauve but their relations quickly soured, partly owing to Vincent's unwillingness to accept some of Mauve's teaching methods. The conflict with his father was discussed by

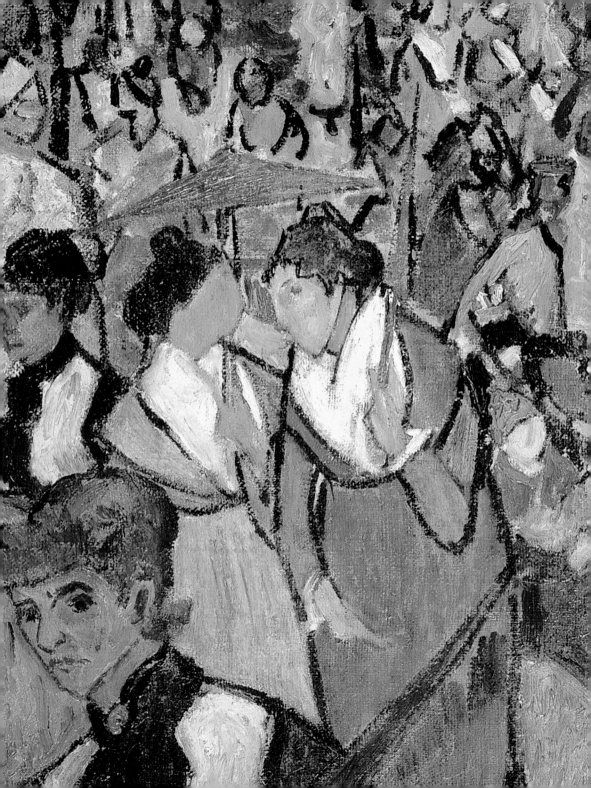

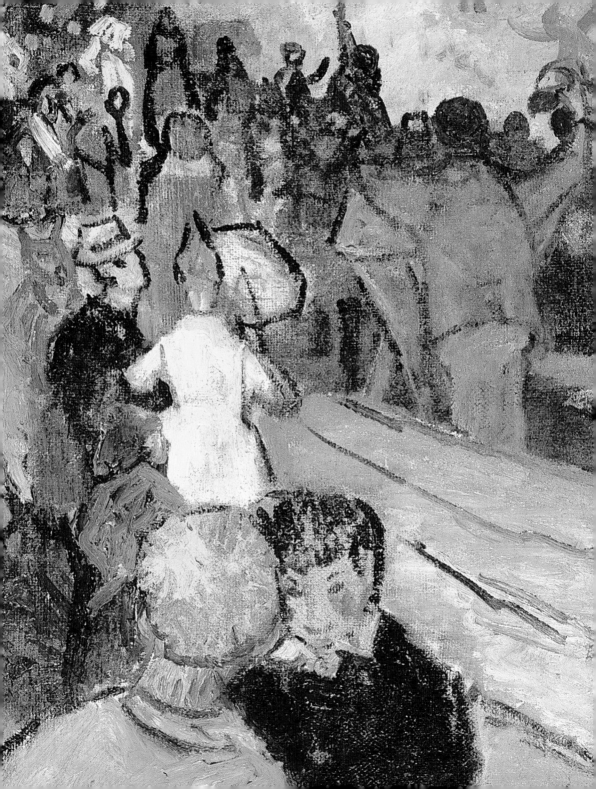

the two brothers and this is one of the cases when Theo's letter was also preserved. The epistolary exchange sheds light on their relationship, on the behavior of the younger brother, which was certainly not one of compliance and also rather critical, and on Vincent's religious sense, which was far from ostentatious piety. "what the devil made you so childish and so shameless as to embitter Father and Father's life and render it almost impossible by setting about things in the way you did? [...] It is Mauve who attracts you at the moment, and, carried away as usual, you find anyone who is not like him objectionable." Vincent replied, "That reproach 'embitter Father and Father's life' is not yours. That is one of Father's Jesuitisms [...]. As for Mauve [...] If I love someone or something, then I do so in earnest and sometimes with real passion and fire, but that doesn't make me think as a matter of course that only a few people are perfect [...]. If Father refers to my saying that I haven't given two pins for the morality and the religious system of the clergy and their academic

ideas, then I absolutely refuse to take that back, for I truly mean it" (letter to Theo 169, January 7 or 8, 1882).

After an unreciprocated love for his cousin Kee, Vincent met a prostitute named Clasina Hoornik, called Sien, who was already the mother of a girl of five and again with child. With the twin desire of redeeming her and finally having his own family, Vincent presented her at home with the intention of marrying her, in spite of the expected ostracism of his relations. In an attempt to earn enough to live, he planned to become an illustrator and so purchased several numbers of the famous English magazines "Graphic" and "London News." He also received his first commission: his uncle Cornelis, who was also an art dealer, asked him to produce twelve pen drawings of views of The Hague, which was soon followed by a second order. Afflicted as always by financial problems, and with the need to pay his models, Vincent wrote an enthusiastic letter to Theo imagining himself to have "set himself up" and inciting his

brother to give up dealing and also become an artist. However, his plans were soon shot down: Cornelis did not like the new series of drawings, which were a verist reproduction of the city suburbs and their squalor. Vincent also understood the impossibility of reconciling this planned family life with the exclusiveness he intended to dedicate to his artistic career and broke with Sien. In September 1883 he went to Drenthe in northern Holland that had previously inspired landscape artists like his friend Van Rappard, Mauve, and Max Liebermann, one of the most important German artists of the late nineteenth century.

Though he continued to draw, Van Gogh began to devote himself intensively to oil painting, representing the lonely countryside and the inhabitants working in the fields in the great tradition of Dutch painting of the seventeenth century and the school headed by Millet that illustrated the life of rural laborers. The sense of isolation and the difficulty of finding models among the diffident farm laborers prompted another move. Van Gogh returned to his parents' home in Nuenen, where his father been appointed priorate. He stayed with them for almost two years, consolidating and developing what he had learned till then, and producing approximately two hundred paintings, besides numerous drawings and watercolors, including the masterpiece of his Dutch period, *The Potato Eaters* of 1885, which was a sort of summary of his interests and studies. The paintings executed in Nuenen are based on few subjects that he repeatedly studied: landscapes, peasants, and weavers. For some time he had been working on a series of "types of Brabant," dark, earthy portraits of people at work or rest. Following the ideal developed by Millet, in these portraits Van Gogh saw the incarnation of a hard but genuine life lived in symbiosis with nature, but, shunning the notion of watering down their sufferings, he depicted his dirty and humble subjects exactly as they were. In a key letter for understanding *The Potato Eaters*, he wrote, "I've held the threads of this fabric in my hands all winter long and searched for the

definitive pattern, and although it is now a fabric of rough and coarse appearance, the threads have none the less been chosen with care and according to certain rules. [...]I wanted to convey a picture of a way of life quite different from ours, from that of civilized people. [...] anyone who prefers to have his peasants looking namby-pamby had best suit himself. Personally, I am convinced that in the long run one gets better results from painting them in all their coarseness than from introducing a conventional sweetness" (letter to Theo 370, April 30, 1885).

The "uncivilized" quality of peasant life became synonymous with simplicity and even with hope for a better world, not polluted by the hypocrisy of city dwellers. Although these convictions may seem to us ingenuous today, authenticity, naturalness, and truth all lay at the heart of the aesthetic debate of the time, from the novels of the leader of the French naturalist school, Émile Zola, to the writings of the English historian and essay writer Thomas Carlyle. Van Gogh's vision, however, was not so much one of a political militant (though he had placed himself "in the front line" in the Borinage) as one of a nostalgic who dreamed of a return to a primitive order.

The painting of peasants brought him a small commission: a jeweler from Eindhoven, Charles Herman, asked him to produce some sketches for the decoration of his living room, for which Van Gogh took inspiration from Millet's *Seasons*. Herman, who was himself an amateur painter, made paintings from the sketches himself but, through Herman, Vincent struck up friendships with other amateurs to whom he sporadically gave lessons in painting. Though profitable artistically, the Nuenen period brought more negative events in Vincent's personal life. Another love affair opposed by the respective families led to a suicide attempt by the girl involved, and, in March 1885, Vincent's father died unexpectedly; despite their relations being difficult for some time, the event had a profound effect on the painter. In September the same year the Catholic curate of the city

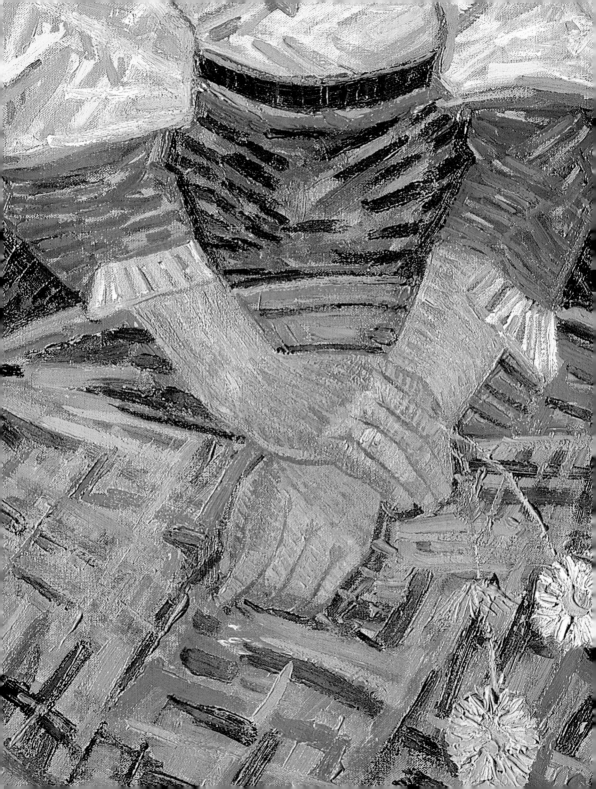

forbade the citizens of Nuenen from posing for Van Gogh as he was suspected of having gotten pregnant a young girl who had posed for him. At the end of the year Vincent moved on once more, this time to Antwerp.

During the previous months of incessant reading, he had discovered the theory of colors put forward by Eugène Delacroix, the great French romantic painter who, in the first half of the nineteenth century, had painted the colors and sensuality of North Africa after depicting the libertarian ideals of the Revolution. Van Gogh had never seen in person any of Delacroix's works, his energetic brushwork and bright tones but he got an idea of it through reading the writings of the freelance journalist Charles Blanc. He too began to enliven his own palette, prompted by admiration for the rich use of color, heavy with reds and whites, of the great seventeenth-century painter Rubens, whose works he could admire in Antwerp, his newly adopted city. It was also in Antwerp that Vincent discovered Japanese prints: initially he used them as wall decorations for his room but their style later influenced the development of his own painting.

After centuries of isolation, in the 1850s Japan had opened her ports to the West and set in motion an exchange of diplomatic and commercial ties that had inevitable consequences on the world of art. A preference for graphical works—prints were much cheaper and easily transportable than paintings—and the diversity of subject and style gave oriental art an air of exoticism that resulted in its becoming a real cultural phenomenon so broad that the term "Japanism" was coined. Fashion, decoration, figurative art, and literature were all inspired by Japanese culture. From the 1860s the American painter James Whistler, who had moved to Paris, began to draw on the works of Hokusai and Hiroshige by painting models in kimonos in poetic settings with decorative, two-dimensional backgrounds. The impressionists too, with whom Whistler was in contact, were fascinated by the diagonals and transformation into silhouettes of objects and

figures, and it is easy to see the effects on the paintings of Manet, Monet, and Degas. Paris became the center from which *Japonisme* spread: in the same way that Rome had been the world capital of art in the sixteenth century, Paris became the focus of stylistic innovation in the second half of the nineteenth century and Van Gogh, who was being kept constantly up-to-date by Theo and his readings on painting, moved there himself in March 1886, installing himself in the house of his brother.

Although he challenged the limitations imposed on him by the rigidity of academic teaching, Vincent had studied at the École des Beaux-Arts. Though he had effectively taught himself to paint, he never refused traditional teaching methods. The manuals written by Bargue were commonly used in technical schools and Theo's letters often referred to the academic distinction between studies and finished works in the same way that anatomical studies and copies of works by masters lay at the base of the

student curriculum. Perfectly aware of his artistic shortcomings, Van Gogh continued to practice with an iron self-discipline throughout his life, invariably resorting to methods that had already been tested and even making use of perspective (something he commented upon to Theo as being a fundamental tool). In a letter he claimed that "There are laws of proportion, of light and shadow, of perspective, which one must know in order to be able to draw well" (letter to Theo 138, November 1, 1879). Once he had arrived in Paris he attended various lessons in the studio of Félix Cormon, a very well known academic painter at the time, whose teaching methods were less rigid than the traditional ones and consequently favored by many young painters. At Cormon's studio Vincent met Toulouse-Lautrec and Émile Bernard, while Theo, who in the meantime had been made a director of a branch of Boussod & Valadon (which succeeded Goupil & Cie), introduced him to Monet, Renoir, Degas, Pissarro, Sisley, and the pointillists Seurat and Signac. However,

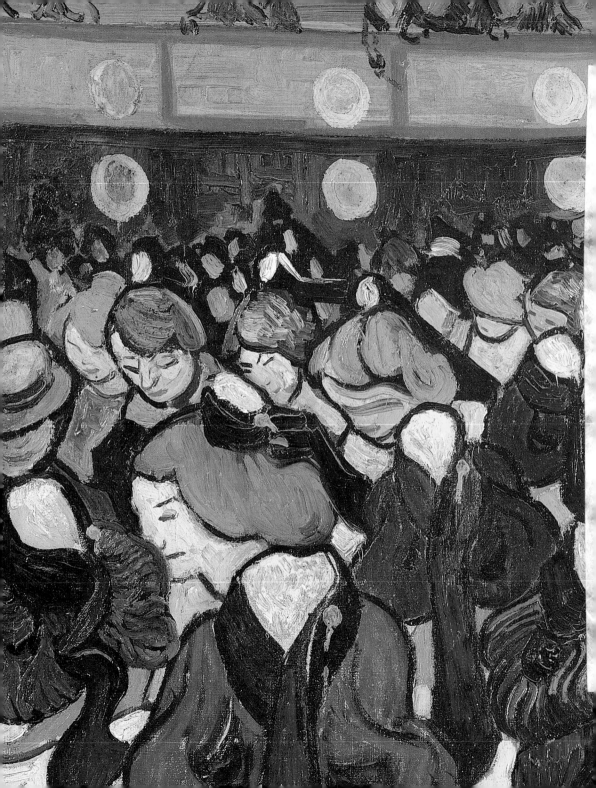

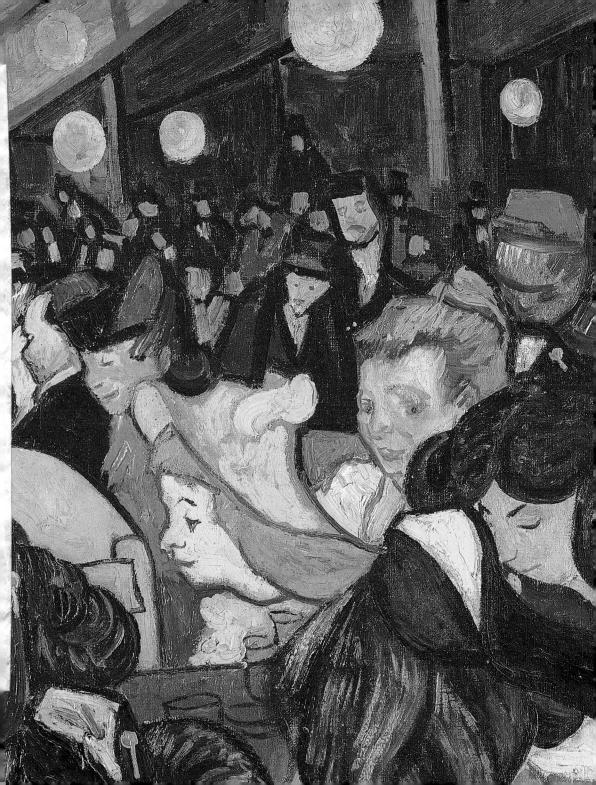

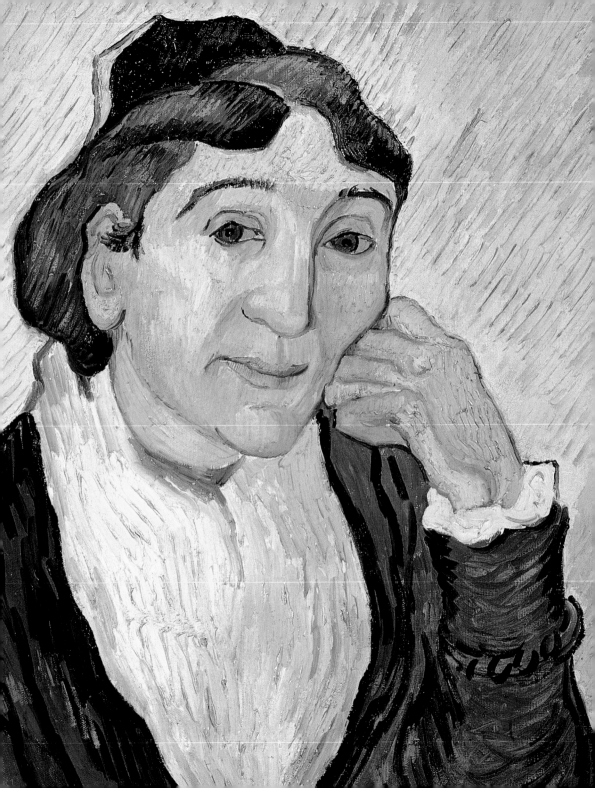

rather than their painting, Van Gogh was initially attracted by the still lifes of Adolphe Monticelli, a romantic colorist in the same vein as Delacroix, who painted using lively, mellow, brilliant brushwork. Initially Vincent had not at all liked the works of the impressionists, who were by then fairly well known in France but completely unknown abroad. As he wrote to his sister Wil, "when one sees them for the first time one is bitterly, bitterly disappointed and thinks them slovenly, ugly, badly painted, badly drawn, bad in colour, everything that's miserable" (letter to Wil 4, June 22, 1888). We see that Vincent often had recourse to traditional criteria in his early judgment of the impressionists, that is to say design and composition. Shortly after his arrival in Paris, the painters who interested him, besides Monticelli and the Barbizon artists, were conventional artists like Léon Lhermitte and Bastien Lepage, who painted rural laborers with a muted palette and a rather pious tone, and Jean-Louis Meissonier, one of the most famous painters of the age, whom Van Gogh envied for his technical skills. It is also probable that his observation on impressionist paintings that "bad in color" sprang from a comparison with the works of Monticelli and Delacroix, who used vivid, dazzling tints.

Soon however he changed opinion and, despite the fact that he did not consider himself an impressionist, he lightened his palette notably and expressed great admiration for Degas's nude females and Pissarro's landscapes. Indeed, Van Gogh was certainly closer to Pissarro, who was considered the heir of Millet, than to Renoir or Monet. Pissarro, a friend of Theo, was always attentive to young painters and, as had occurred with the work of Cézanne and Seurat, he was one of the first to recognize Vincent's potential and talent.

In addition to having viewed the impressionist paintings at the seventh exhibition of the group and at the Salon des Indépendants, Van Gogh had begun to visit the store of Père Tanguy, one of the paint dealers who sold at a low price works by young, unconventional painters that were considered unacceptable

elsewhere. It was at Tanguy's that Vincent struck up a friendship with Émile Bernard, who had been expelled from Cormon's studio due to the unconventionality of his painting, and Paul Signac, who had adopted the pointillist theory of color espoused by Seurat. Interested in the scientific division of color championed by the pointillists, Vincent began to experiment with combinations of complementary colors and abandoned the social themes he had so enthusiastically embraced in Holland. Taking up city views once again, he applied Seurat's technique to several paintings of Montmartre and to Asnières in the suburbs, first with Signac and later Bernard. He also met Gauguin on his return from Brittany where he was the leader of the Pont-Aven school. The school was a group of artists who had escaped from the city in search of an unspoiled and "primitive" place, and who gave rise to one of the most interesting trends in the symbolist movement.

In 1887 Van Gogh organized an exhibition at the Restaurant du Châtelet on Boulevard de Clichy with the intention of bringing all his new friends together. Bernard, Gauguin, and Louis Anquetin (another member of the Pont-Aven group) exhibited several canvases each. To Van Gogh's displeasure the neoimpressionists did not get involved, for instance Seurat, Signac, and even Pissarro, as they were opposed to Bernard and Gauguin, who were ferociously against the scientific rationality of their own painting. The exhibition was called *Peintres du petit boulevard* in contrast to the *grands boulevards* where the important galleries (Boussod & Valadon, Durand-Ruel, and Georges Petit) exhibited the impressionists. The exhibition was visited by a certain number of artists and dealers but Van Gogh, after an argument with the owner, soon withdrew his own paintings. With Seurat and Signac he exhibited instead at the Théâtre Libre that had just been opened in Pigalle by André Antoine.

Life in Paris did not turn out to be at all simple for Vincent. Cities had never been his ideal environment and his irritability did not

foster close cohabitation with his brother Theo. He also felt the need to absorb the myriad of artistic stimuli at a time when his artistic energy began to flag. Encouraged by Gauguin's stays in Brittany, Van Gogh decided to leave Paris in search of a solitary and relaxing setting which, in his imagination, would become a European Japan, in other words a new earthly paradise. Attracted by the bright colors of the south and the idea of visiting the places painted by Cézanne, who had returned some time before to his birthplace of Aix-en-Provence, and Monticelli, who had been born in Marseilles, Van Gogh left for Arles in Provence in February 1888.

His new destination fully lived up to his expectations. The bright colors of the south were exactly what he was looking for and what he needed to develop his painting. The first works he produced there were largely influenced by impressionism but he quickly evolved his own style, ceaselessly testing the expressiveness of color and the use of different types of brushstroke—long, staccato, and curved—to transfer his moods onto the canvas. Van Gogh was perfectly aware of his own development and was satisfied with the results he was achieving. He wrote to Theo that he was in a "feverish state" and observed, "I should not be surprised if the Impressionists soon find fault with my way of working, for it has been fertilized by Delacroix's ideas rather than by theirs. Because instead of trying to reproduce exactly what I have before my eyes, I use color more arbitrarily, in order to express myself forcibly" (letter to Theo 520, August 11, 1888). As he explained to Gauguin, colors had become for him "poetic concepts," the intensification and distortion of which allowed him to reach the deeply searched for coincidence of visual and psychical perception, so that vision and feeling, eye and heart sang in unison in his paintings. He was guided by emotion, that expressive urgency that had always pushed him to throw himself body and soul into a creative act until he bordered on the ridiculous. Émile Bernard recounted that

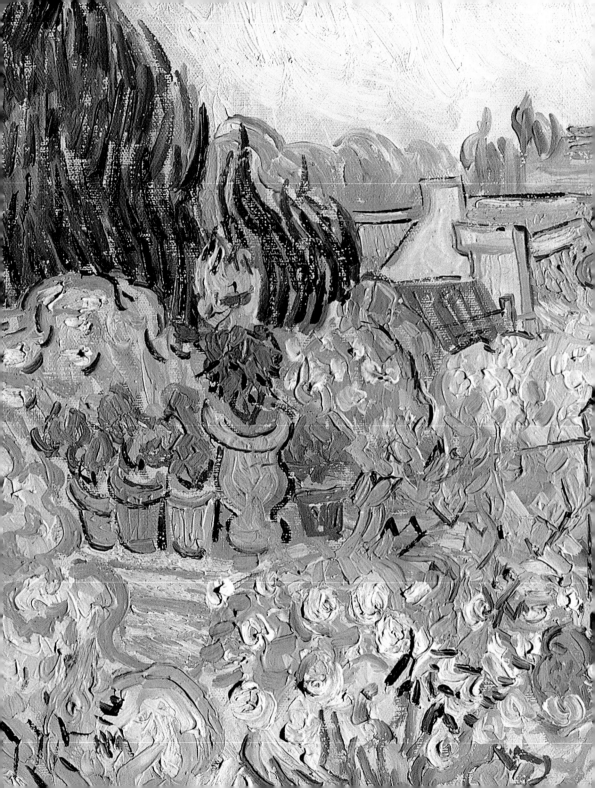

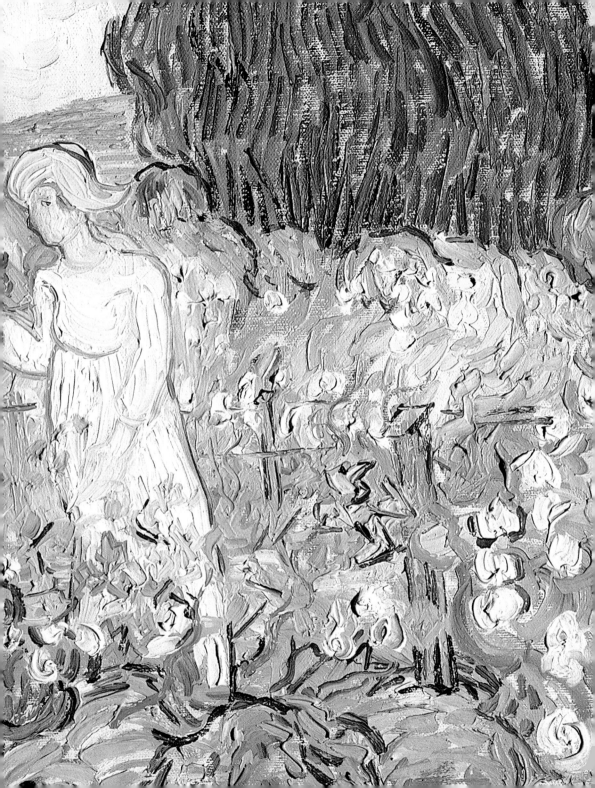

in Cormon's studio "he made three studies in each session, getting himself all messy, incessantly restarting on new canvases, painting the model in every aspect, while the mean students that laughed behind his back took eight days to stupidly copy a foot" (this passage is taken from an unpublished manuscript on Van Gogh from 1889 and is quoted by J. Rewald in *Post-Impressionism from Van Gogh to Gauguin*, Museum of Modern Art, New York, 1956). In addition to emotion and feeling, and despite the fact that he stated he allowed himself "to go without following any rule," Vincent now had the requisites to give substance to his inspiration. Combined with what he had learned in Paris, his study of Japanese prints was achieving its greatest results, which caused him to simplify forms ("Now I am trying to emphasize the essential by neglecting everything that is banal," he wrote to his sister Wil shortly after his arrival in Arles), adopting close-up views and diagonal slants, and contrasting brightly colored zones of the painting. Though he finally felt he was on the right path, he wanted to share his ideas with friends and colleagues, not just through busy correspondence but at a personal level by trying to create a community of painters. Different groups of artists had been important during his development—the schools of Barbizon and The Hague, the impressionists and the pointillists—and Vincent was convinced that only through working as a group was it possible to explore a new direction with sufficient force. He believed that the Pont-Aven school had already achieved that but, on the one hand, the town in Brittany was by then visited by a large number of artists of different, even contradictory, styles, and on the other, Van Gogh was sure that only the south of France, the land of Cézanne and Monticelli and his favorite authors, Émile Zola and Alphonse Daudet, could offer the right setting. Caught up in his usual enthusiasm, he rented the Yellow House in Arles (featured in a famous painting in Amsterdam) and wrote to Gauguin and Bernard inviting them to join him. With Louis Anquetin these two had

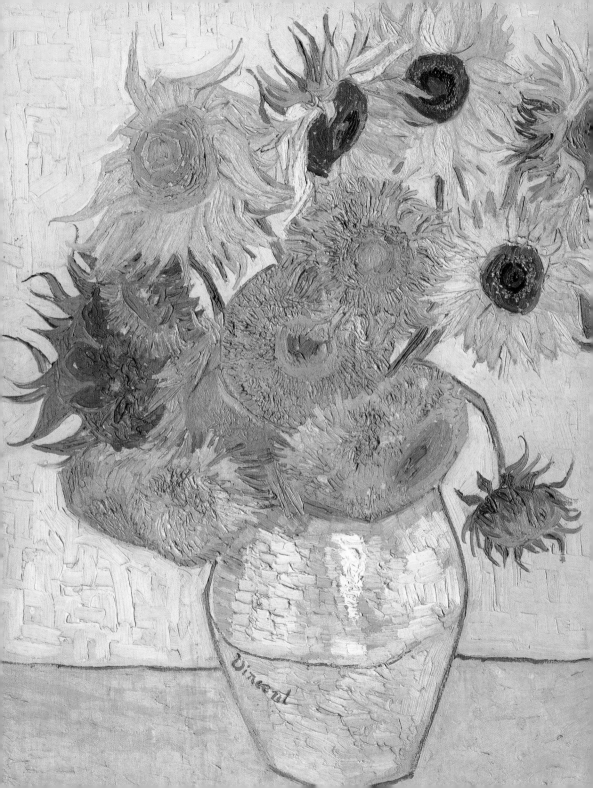

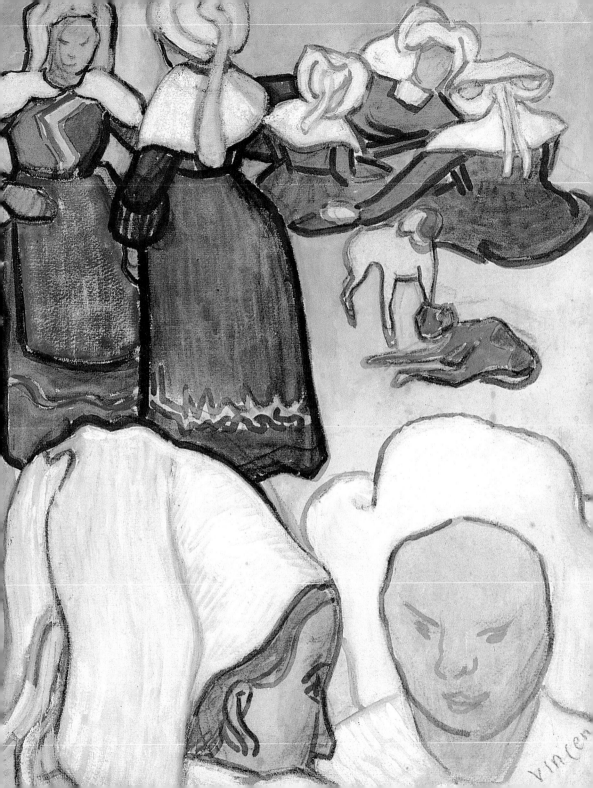

developed a new style, very different from impressionism, that was highly intellectual, parallel to the use of symbolism in literature. Taking their cue from the two-dimensional surfaces of Japanese prints, Bernard and Gauguin used outlines to carefully separate all the different forms from one another, applying the colors flatly to create both a decorative and abstract effect. In an article published in May 1888 in the *Revue Indépendante*, the art critic Édouard Dujardin called their style *cloisonnisme* referring to the technique used by enamellers during the Middle Ages when they inserted colored glass paste in gilded settings. He also explained how the novelty consisted in the rationality and systematic nature of the construction, "free from the romanticism of passion." Quite different from the results achieved by the detested neoimpressionism with its block forms and static compositions, the works by Bernard and Gauguin were evocative and charged with expectation.

Van Gogh's invitation did not bring any immediate acceptance until Theo, encouraged by his brother, agreed to exhibit Gauguin's paintings, prompting him to travel down to Provence. Vincent felt enormous admiration for Gauguin and ardently wanted the company of someone with whom to share his ideas and time. He was experiencing a period of emotional instability during which he worked ceaselessly, eating irregularly and keeping himself going with drink and tobacco. Very excited as he awaited his guest, he wrote to Theo that he was "once more almost reduced to a state of madness [...]. And if it were not that I have almost a double nature, like that of a monk and that of a painter, I should have —and that long ago—been reduced completely and utterly to the aforesaid condition" (letter to Theo 556, mid-October 1888). Gauguin, who had dreamed of returning to Martinique and considered himself clearly superior to his colleagues, did not share his friend's enthusiasm. However, after a series of delays, he reached Arles at the end of October 1888. The Provençal atmosphere did not arouse in him the same fascination that it did

in Van Gogh, who did his utmost to make his friend's stay as pleasant and long as possible. However, their characters and artistic inclinations tended to clash. Vincent listened to the advice of one who thought he was a guide, though without following it blindly or abandoning his own ideas. He allowed himself to be convinced to work from memory without the model before his eyes, and during the period they spent together there was undoubtedly a closening of artistic styles that culminated in the painting *Memory of the Garden at Etten* (Hermitage, St. Petersburg). The scene is enveloped in a mysterious atmosphere that was most certainly the result of Gauguin's influence. Yet, though not rejecting a priori the idea of making use of this technique at some future stage, Van Gogh quickly understood that the abstractions of the Pont-Aven group were not for him. As he had previously written to Bernard, "I am interested in all that really exists; I have neither the desire nor the courage to search for the ideal" (letter to Bernard 19, early October 1888). With its flat blocks of color, cloisonné was the opposite of Van Gogh's charged, expressive brushwork, and the more Gauguin wanted to distance himself from reality, the more Vincent wished to grasp its emotion. Van Gogh was certain he had learned a lot from Gauguin, and after the latter's departure from Arles, Van Gogh showed great gratitude toward him. In the space of little more than a month though, their relations became increasingly tense and, in *Avant et Après*, his memoirs written fifteen years later, Gauguin wrote that without any warning during a normal evening in the café Van Gogh flung a glass of absinthe over him. Although he then decided to return to Paris and let Theo know, he yielded to his companion's entreaties and remained in Provence. Yet Vincent, presaging the end of the "studio in the south" and, therefore, the collapse of his dream, became prey to growing tension until one night, having seen Gauguin leave the house, he cut at his right ear with a razor. According to the version in *Avant et Après*, Vincent attempted to attack his friend with the razor but then

turned it on himself. It should be said that Gauguin's memoirs were artfully composed to give a more constructed than real image of himself, and an exaggerated one of Van Gogh's madness and his artistic debt to Gauguin. The version he told Bernard soon after the incident was different in that it did not mention the presumed attack on himself. Nonetheless, the fact remains that Vincent, already the victim of exhaustion, performed his desperate act, handed the ear to a prostitute and returned home where the next morning he was found unconscious by the police. Gauguin, who had spent the night in a hotel, found out the events of the night the next day and left for the capital without seeing his friend, though he informed Theo of what had happened.

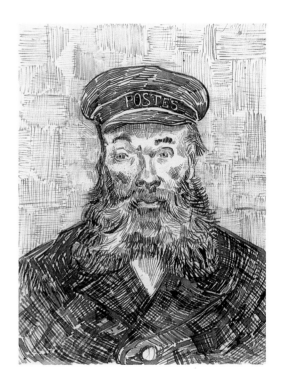

Once he had recovered after two weeks of convalescence, in the presence of his brother, Vincent wrote to Gauguin pleading him not to "speak badly of our poor little yellow house" (letter added to letter to Theo 566, January 1, 1889). Although he later showed no rancor toward his friend, even deluding himself that

Portrait of Doctor Felix Rey
(detail), 1889
Moscow, The Pushkin State
Museum of Fine Arts

it was possible to start their living together again, he wrote to Theo when he came out of hospital that Gauguin seemed to him like "the little Bonaparte tiger of impressionism who also presented himself in Paris afterward and who always left the armies in the lurch" (letter to Theo 571, January 17, 1889).

In following letters, Vincent wrote serenely and knowledgeably, stating that he was in no condition to invite other painters for fear of a relapse. Yet though he did his best to recover, a second crisis obliged him to return to hospital. He restarted painting once he was let out again, but the citizens of Arles signed a petition to have him interned. In the hope of calming their fears, Van Gogh did not oppose a further return to hospital but his words brimmed over with bitterness: "I am thinking of frankly accepting my role of madman, the way Degas acted the part of a notary. But there it is, I do not feel that altogether I have strength enough for such a part" (letter to Theo 581, March 24, 1889). In May Vincent decided to enter the asylum

at Saint-Rémy close to Arles. At first Theo was against the idea but his brother was resolute on the matter, claiming that he was unable to make any further moves or to live alone. He received no specific cure and was allowed to paint outside the asylum. The place gave him a sense of tranquility but the inevitably depressing atmosphere most certainly did nothing to raise his spirits. He accepted his illness and, in doing so, also a state of existential melancholy in which he lost all hope of being cured. Living with the fear of new hallucinatory attacks, of which he spoke with horror, he was absolutely lucid and referred to painting as his salvation from the complete apathy in which the other inmates lived. Theo's letters, filled as ever with news from the art world, plus books and magazines that his brother sent to him allowed him to stay abreast of events. For his part, Vincent started to paint once more with vigor, producing several views of the garden at Saint-Rémy and fascinated by the cypresses in the surrounding scenery. His style was still

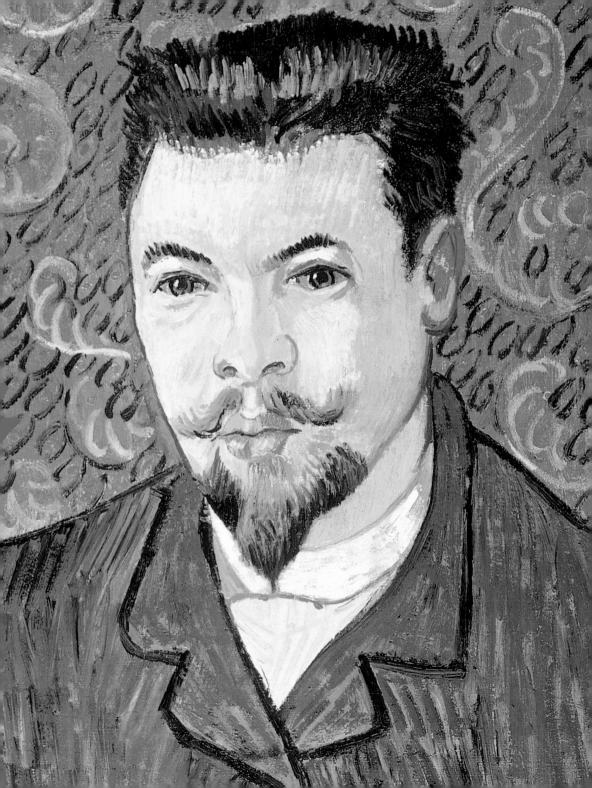

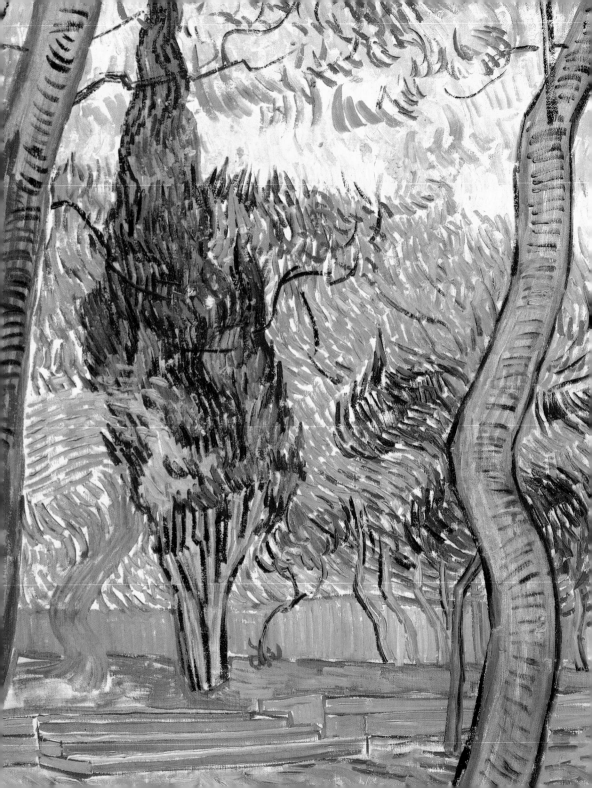

evolving and achieving greater expressivity. He claimed he felt very close to Gauguin and Bernard but his work was moving down very personal tracks far from the sometimes artificial intellectualism of his friends. His source of inspiration was the creation of an art that might console him from the storms of life.

Theo, newly married, liked many of Vincent's new paintings and gave them a very fitting interpretation, showing that Vincent was anything but an isolated painter and that he was in line with the developments of contemporary art even though in a unique and personal manner: "In all of them there is a vigour in the colors which you have not achieved before—this in itself constitutes a rare quality—but you have gone further than that, and if there are some who try to find the symbolic by torturing the form, I find this in many of your canvases, namely in the expression of the epitome of your thoughts on nature and living creatures, which you feel to be so strongly inherent in them" (letter from Theo to Vincent 10, June 16, 1889). Theo did not

always find the evolution of Vincent's experimentation attractive, particularly when he approached the new course set by Bernard and Gauguin, for example in *The Starry Night*, which Theo considered not very spontaneous, and was convinced that, "the search for some style is prejudicial to the true sentiment of things" (letter from Theo to Vincent 19, October 21, 1889). Vincent, ever ready to back up his ideas, replied that his search for a personal style should be seen as a search for greater deliberateness, as a marked expression of his ego within the subjects painted. At the time, he was pretty much in the dark as to the latest developments in Pont-Aven and when contact was re-established with Bernard and he discovered that the latter had veered toward mysticism and religion, he criticized this direction in no half-terms, calling it artificial and affected and stating again that abstraction had no interest for him (letter to Bernard 21, early December, 1889).

A few months later Van Gogh was struck once more by a strong attack that sent him

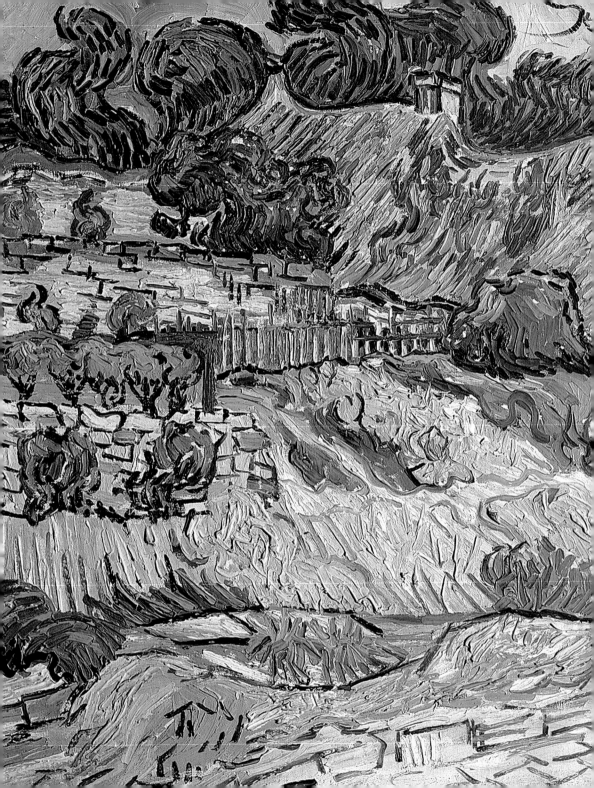

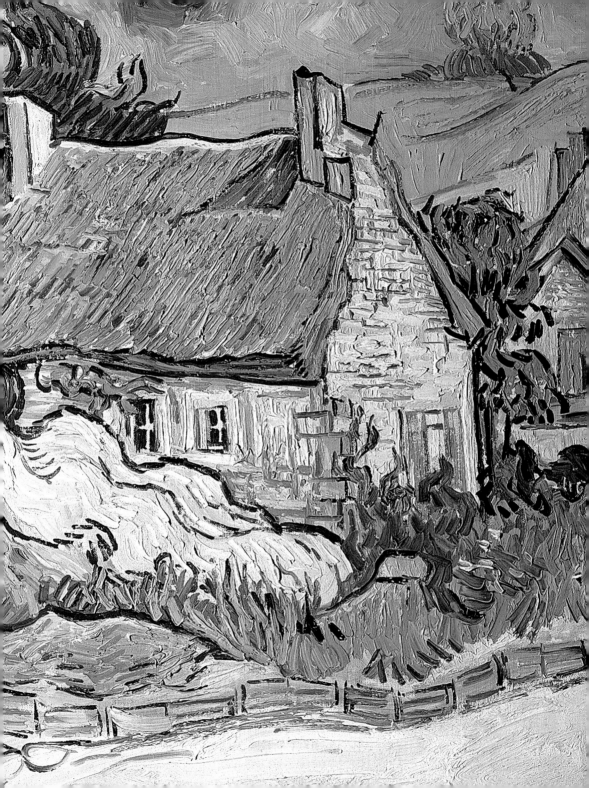

into deep depression worsened by a doctor's restriction on his painting as, during the last attack, he had attempted to swallow his paints. Nonetheless, he did not resign himself and when he felt better he wrote to Theo, "I am trying to recover, like someone who has meant to commit suicide, but then makes for the bank because he finds the water too cold" (letter to Theo 605, September 7 or 8, 1889). In November Vincent was invited to take part in the following year's exhibition of the group "Les XX" in Brussels. With the exception of a few shows in Paris, some of which were organized by himself, Van Gogh had never participated in an exhibition and those held by the Belgian group were famous internationally as a window on the most progressive trends in art. The founders had always stood out for their ability to discover new talent and one of their emissaries had specially visited Père Tanguy's store to see the works by the Dutch artist and the equally unknown Cézanne (who was also invited). The invitation did not rouse much enthusiasm in Vincent but he chose six

paintings with care, including two versions of sunflowers, "thinking that all six together, chosen thus, will create an effect of very varied colors" (letter of November 20, 1889, published by the leader of the group, Octave Maus, in his memoirs).

Unable to leave the asylum, Vincent executed a number of copies of works by his favorite, Millet, and Delacroix, Rembrandt and Daumier and began to nurse the intention of returning north in order to escape his increasingly suffocating environment. His hope was to live with another painter and both friends thought of Pissarro, whom they both held in great esteem and who had always been kind toward young talents, Vincent included. Pissarro's wife, however, feared the presence of an unstable person in contact with their children, some of whom were still young, and opposed the idea, so Pissarro suggested Paul Gachet, a doctor in Auvers-sur-Oise, who was an art lover and the friend of various artists.

While he prepared himself psychologically for departure, he received from Theo an

article published in January 1890 by the young critic and symbolist writer Albert Aurier in the first number of the *Mercure de France* entitled *Les isolés: Vincent van Gogh (Unknown Painters: Vincent van Gogh)*. The author had been prompted by Émile Bernard to write something on the latter's promising but unknown friends and the article had been written with the intention of following it up with more on other painters, Gauguin first of all. Aurier had been fascinated by Van Gogh's works and recognized their extreme originality and power. He dwelt on the "simple truth of his art" and on "the excess" and "style" of the painter, "a extremist [...] who perceives with abnormal, perhaps painful, intensity," achieving "a masterly synthesis" with his "vigorous, [...] brutal execution." Somewhat surprised, Van Gogh viewed the article with a mixture of pride and worry, genuinely believing that Aurier had overpraised the value of his paintings and writing to him that the phrase "he is the only painter that perceives the chromatism of objects with this inten-

sity"—perfect for his work—should rather be applied to Monticelli. What he firmly rejected was the attempt to label him as a symbolist: in his previous letter to Bernard, when he had criticized his "abstractions," Vincent had written that he wanted to "immerse myself in reality, without any [...] Parisian prejudice," and to Aurier he wrote, with unusual tact, "I do not see the use of all that sectarian spirit." The article was well received because at the same time Vincent's paintings in the exhibition of Les XX were causing a real stir and resulted in Toulouse-Lautrec challenging the traditionalist painter De Groux to a duel for having called Van Gogh "a charlatan." At the same show one of Vincent's paintings was purchased, something that had never happened before. It was the *Vigne rouge (Red Vineyard)*, which was bought for four hundred francs (a rather low price) by the painter Anna Bloch; Anna was the sister of the poet Eugène Bloch and had been portrayed by Vincent. The effect of these different items of news probably shook the painter: he suffered another heavy attack

that lasted for two months and from which he came out completely desperate but determined to leave the south.

On May 16, 1890, a year after he entered the asylum at Saint-Rémy, Vincent left Provence for a brief stop in Paris on his way to Auvers. The last few months had been serene: Theo had had a son and named him Vincent, and ten of the artist's paintings from Arles and Saint-Rémy had met with great success at the new exhibition of the Indépendants, and were especially appreciated by his colleagues, including Monet, Pissarro, and Bernard. Even Gauguin had written a letter filled with compliments. Van Gogh had then enjoyed new and creative happiness and painted the blooms of spring in a series of extraordinary canvases.

After a visit to the Salon, where he was impressed by the work of Puvis de Chavannes, he reached his new destination. He immediately found himself in harmony with the eccentric Dr. Gachet and in the space of two weeks had begun his portrait. Gachet's company allowed Vincent to discuss his interests, something that he had missed for so long. Almost convinced that his illness had been caused by the air of the south, Vincent again took heart and considered the idea of paying a visit to Gauguin in Brittany (who, naturally, gave a rather tepid reply). What upset this new serenity was a series of problems suffered by Theo: first, as his superiors at Bousson & Valadon did not share his ideas on contemporary art, Theo broke with them after they lost their confidence in him, and second, both Theo's wife and son fell seriously ill. Even though Theo tried hard not to let his worry show, Vincent was heavily affected by the situation and, knowing that his own survival was linked to the economic fate of his brother, he was struck by guilt. He went to see Theo in Paris, where he was introduced to Aurier and received a visit from Toulouse-Lautrec, but, far from being reassured, on his return to Auvers, he wrote to his brother, "I have set to work again, though the brush almost falls from my

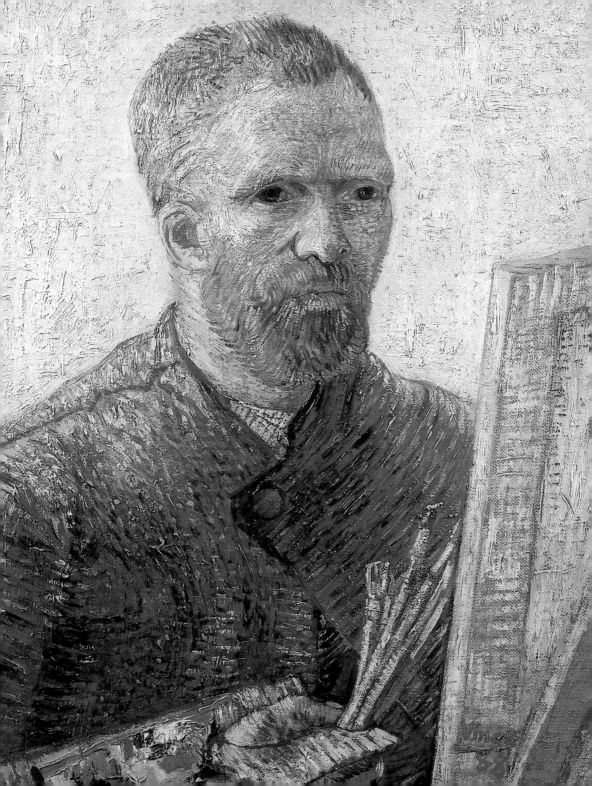

fingers" (letter to Theo 649, July 10, 1890). Gripped once more by feelings of anguish, he had a violent quarrel with Gachet that led to the breaking of relations. He closed himself up in complete isolation, devoting himself body and soul to painting that expressed "sadness and extreme loneliness" (letter to Theo 649, July 10, 1890).

Terrorized by the idea of being subject to new attacks, on July 27 he shot himself with a pistol in the fields where he had gone to paint. Wounded but able to walk, he shut himself in his room and when the owner went to look for him, Vincent told him he had tried to kill himself but failed. He wanted to see Dr. Gachet but refused to give the doctor Theo's address. Nevertheless, the doctor managed to inform Theo, who rushed to Auvers. On his arrival Vincent welcomed him saying, "No tears, I did it for the good of everyone." Though his constitution had always been strong in the past, he had lost the will to live and died during the night of July 29. Many of his friends were present at his funeral,

including Père Tanguy, Lucien Pissarro, and Émile Bernard, whereas Gauguin, who had sent a note, wrote shortly afterwards to a friend, "Let's consider the matter dispassionately; perhaps there is something to be learned from the dreadful business of Van Gogh."

Vincent's calculations soon turned out to be completely mistaken: for Theo the blow was terrible and he dedicated all his energies to organizing a retrospective for his brother's works, asking help from Bernard and planning a large catalog with Aurier in which he thought he might insert some of the letters between himself and Vincent. Theo had Paul Durand-Ruel in mind, but the famous dealer of impressionist works was himself close to bankruptcy and refused to lend his gallery. Instead Theo received immediate support from Octave Maus and Signac (who was by now a permanent member of Les XX). But Theo's plans were never realized: in just a few weeks he, too, lost his reason and died in Holland on January 25, 1891, less than six months after his brother. However, his friends kept their word

and the ten works painted by Vincent exhibited at the Salon des Indépendants in 1891 were the most admired of all. The critic Octave Mirbeau dedicated a passionate article to Van Gogh, deploring his early death and the fact that he had "died so obscure, so unknown."

In 1879 Van Gogh had written to his brother from the Borinage, "I still can find no better definition of the word art than this, '*L'art c'est l'homme ajouté à la nature*' (art is man added to nature)—nature, reality, truth, but with a significance, a conception, a character, which the artist brings out in it, and to which he gives expression, '*qu'il dégage,*' which he disentangles, sets free and interprets" (letter to Theo 130, June 1879). This thesis remained valid in all the artist's work. Rejecting the abstractions toward which symbolism was heading, Van Gogh was always faithful to nature, considering reality his only source of inspiration and constant model. His process was exactly the opposite of that described by Aurier in his article in the *Mercure de France*,

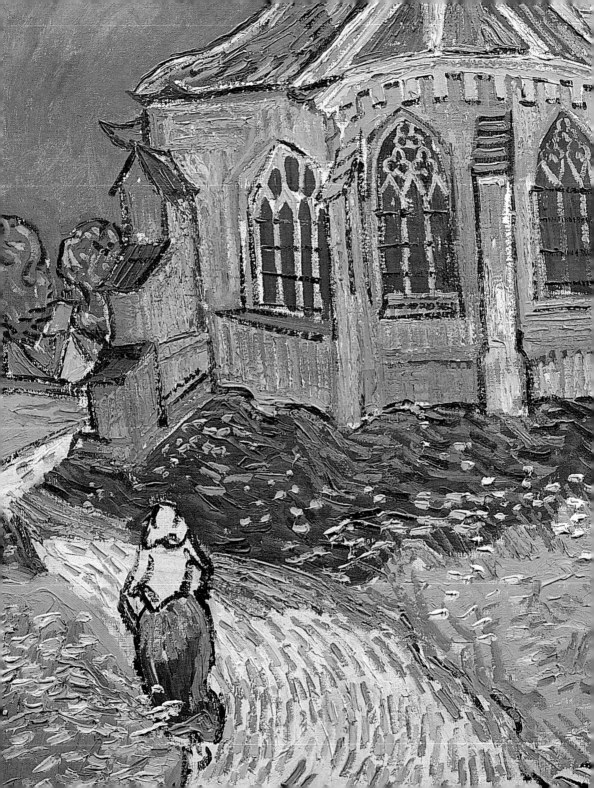

in which he referred to Van Gogh as a symbolist "because he feels the continual necessity of fitting out his ideas with precise, consistent and tangible forms." Vincent worked in the opposite way: as he stated several times in his letters, he found meanings inside nature. His work consisted in interpreting them in a personal manner and making his own emotions surface on the canvas. In July 1882 he wrote to Theo, "It is the task of the painter to allow himself to be absorbed by nature and use his own abilities to express, through his work, feelings in a way that they might be intelligible to others" (letter to Theo 221, early August, 1882). And in 1888 he declared once more, "I cannot invent my painting completely, on the contrary I find it already in nature, all I have to do is to succeed in recognizing its presence there" (letter to Bernard 19, early October, 1888). His main tool for doing so was color, which had stimulated the greatest interest in him from the beginning. The arbitrary use that Vincent made of it was dictated by his conviction that color,

better than any other means at the artist's disposal, was the vehicle of sensation, the best way to express his subjectivity and to succeed in communicating that to others. This belief was not the fruit of just his intuition but had been nourished by long reflection on the theories of Delacroix and Japanese prints that Van Gogh had studied since his period in Holland. In addition, after his move to Paris, it was supported by the works of the impressionists and the scientific studies of the pointillists. His desire for a brighter and luminous chromatism had directed his move to the south of France, in the same way that his long and increasingly sad solitude in Saint-Rémy had led him to tone down his palette and substitute the dazzling yellows, reds, and blues with ocher and pale violets and greens. Even in the many copies he made of the paintings of other artists, color provided the key to his personal interpretation, to the extent that he had written to Theo from the asylum, "to paint bearing in mind the drawings of Millet is to translate them into another language" (letter to Theo

613, autumn 1889). In addition to color he used brushwork as a means of expression. In Paris he had appreciated the freedom with which Monticelli and the impressionists had wielded their brushes, and if at first he had been inspired by them, he had then created a series of personal uses that were in constant evolution and often used in combination. Lines, dots, curls, and spirals alternate in his artistic vocabulary, and the manner with which he applied the paint became a direct expression of his psyche. "Is it not the emotion, the sincerity of the sentiment of nature that guides us? […] Brushstrokes appear with a sequence and concatenation like words in a speech or letter," he explained from Arles (letter to Theo 504, June–July, 1888).

This constant stylistic experimentation and his variations were applied to a fairly restricted range of subjects. Although he was continually searching for new things to represent, Van Gogh concentrated on few genres but depicted them at different moments: the urban landscapes in The Hague and Paris, but also Arles; the countryside, which had been unquestionably the central feature of most of his paintings and drawings throughout his artistic career; his self-portrait, another recurrent theme; and in Nuenen, Paris and Saint-Rémy he had produced various still lifes. When he took the trouble to search out new motifs to paint, he looked for them within his existing fields of interest. In Provence he was attracted by elements not found in the north and which he had never represented before, such as olives, vines and cypresses.

We can therefore see a linking thread, a common denominator in his oeuvre. From the studies of farm laborers at work, to landscapes and portraits, what interested him was authenticity of vision: this did not mean a reproduction in the manner of a photograph but a genuine, personal interpretation of a real, existing model. Like many of his contemporaries, what he was searching for was the possibility of establishing a positive link between man and the natural world. He was in fact anything but isolated on the artistic plane and

perfectly in line with the most innovative experimentation in painting of the era. In spite of choosing to live in places far from the epicenter of the developments in art, he was perfectly knowledgeable of what was happening in Paris through the information he received from Theo and his reading. In his conversations and letters to friends and colleagues he regularly discussed his views and the exhibitions he had organized, as well as the never abandoned dream of creating a community of painters; all these aspects point to the opposite of the presumed myth of the solitary genius. He was firmly convinced that only through the work of a group could the necessary force be created to achieve "the level [...] of the Greek sculptors, German musicians and writers of French novels" (letter to Theo 6, June 6–11, 1888). As we have seen, his work had several points of contact with that of the symbolists—in the search for a personal meaning that transcended the simple reproduction of reality—but was different in its creative procedure. Expression of emotions in brushwork was also explored by Seurat but Van Gogh had no interest in the scientific and consequently rigid approach of his colleague. If his aims were analogous to those of his contemporaries, his means and results were absolutely unique and his painting a fundamental precedent for expressionism.

Shortly before dying he had written to his sisters words that were to be prophetic: "What impassions me most—much, much more than all the rest of my métier—is the portrait, the modern portrait. I seek it in colour, and surely I am not the only one to seek it in this direction." And he added, "I *should like* to paint portraits which would appear after a century to people living then as apparitions. By which I mean that I do not endeavour to achieve this by a photographic resemblance, but by means of our impassioned expressions" (letter to Wil 22, June 5, 1890).

Practically unknown and ignored during his lifetime, Van Gogh later became a very famous artist. The article by Albert Aurier written in 1890 and the presence of his paint-

ings in the Salon des Indépendants marked the start of a fame that was gradually transformed into a legend. A series of writings by Émile Bernard and Aurier were published in the years immediately after his death and from the start of the twentieth century there was no end of publications dedicated to him. His tragic life provided material for many authors: in addition to the already mentioned novel by Meier-Graefe, there was the success in 1924 of the book *La vie tragique de Vincent van Gogh* (*The Tragic Life of Vincent van Gogh*) by Louis Pierard, which was translated into several languages. The first catalogue raisonné appeared very early in four volumes, and ever since 1928 there has been a ceaseless flow of exhibitions, essays, and articles on him and his work. An entire museum was built especially for him in Amsterdam, and his fame was furthered by the publication by Theo's widow of his large and fascinating body of correspondence.

The personal and emotional nature of his work has also contributed to the notion of Van Gogh as a unique artist, different from everyone else despite attempts made to demonstrate to what extent, and with what awareness he was part of the contemporary artistic context. It is, however, undeniable that his dream of creating a community of painters—so that they might jointly further their art—remained unrealized, and though his example was fundamental to many of the later artistic movements, he remained completely without pupils, one of those "meteors" that changed the course of the history of art.

Camille Pissarro had said of Van Gogh, "Either he will go mad or he will leave us all far behind. Which of the two it will be I am not able to foresee."

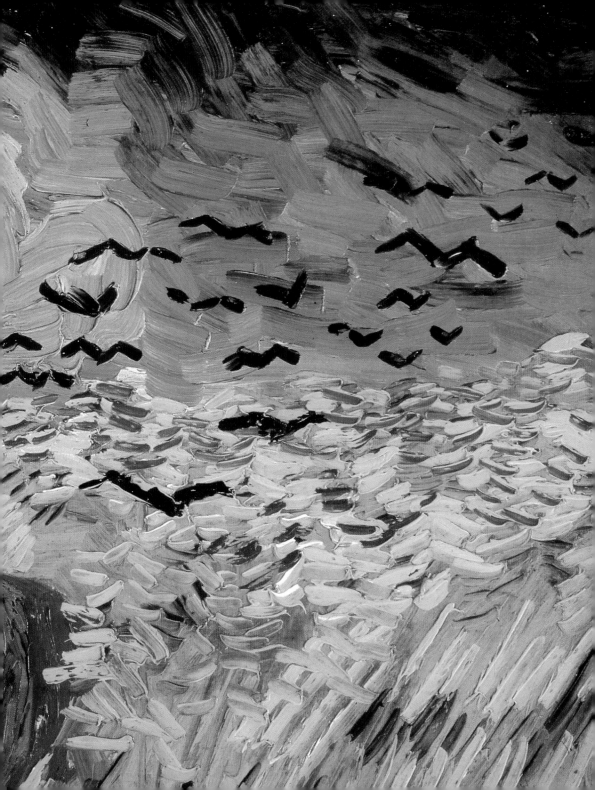

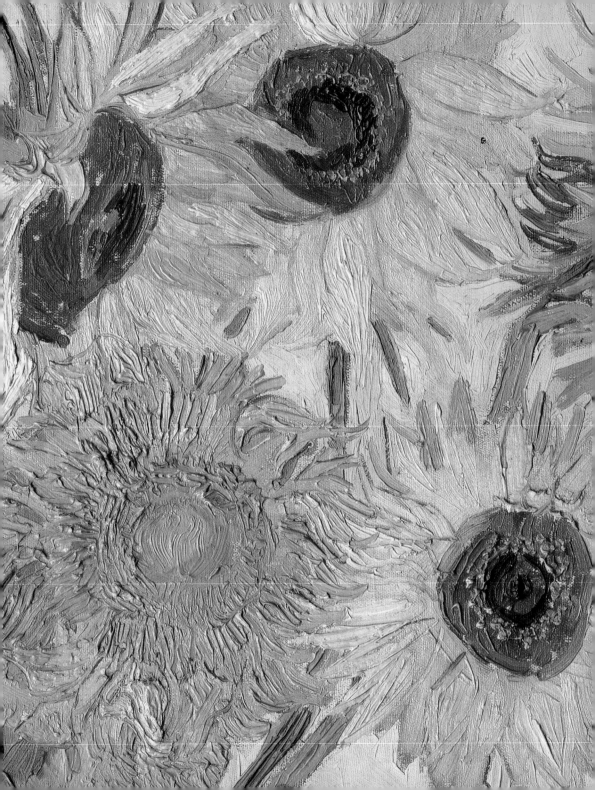

The Masterpieces

Women Carrying Sacks of Coal

1882
Watercolor, 32 × 50 cm
Otterlo, Kröller-Müller
Museum

In 1879 Van Gogh travelled to the Borinage—a mining region in Belgium—where workers lived in miserable conditions. Prompted by a strong religious vocation, he had attended a preachers' seminary and managed to get himself appointed in the Borinage for six months by the Evangelist School of Brussels. The painter was stimulated by the ideals of Christian humanitarianism held by his father, a Protestant minister, but, due to his personal zeal, which bordered on fanaticism, his appointment was not renewed. Vincent had chosen to share the life of the miners completely, living in a hut, sleeping on the floor, and fasting, and even descending into the mine to preach. He made many drawings of the workers and though this watercolor was painted three years later, his memories of life in the Borinage remained vivid. There also existed pictorial precedents for this type of representation in the realist tradition—very different from the idealized scenes painted by Millet—but Van Gogh's work displays the intensity of one who had been present at such scenes. The artist was also a passionate reader of the Victorian historian Thomas Carlyle, who preached a "philosophy of used clothes": the folkloristic garments and Sunday dress in other paintings were not authentic, whereas the clothes actually worn by the miners reflected sorrow, happiness, and passion.

At the end of 1881 Vincent had moved to The Hague to take lessons from Anton Mauve, a cousin-in-law and outstanding member of the pictorial school named after the city. Van Gogh—who was still a beginner despite having executed drawings for some time—produced his first oil paintings under Mauve's supervision as well as many watercolors. In its chromatism and execution this painting reflects the style of Mauve who, in harmony with the colors of Dutch soil, habitually used grays, browns, and off-whites side-by-side.

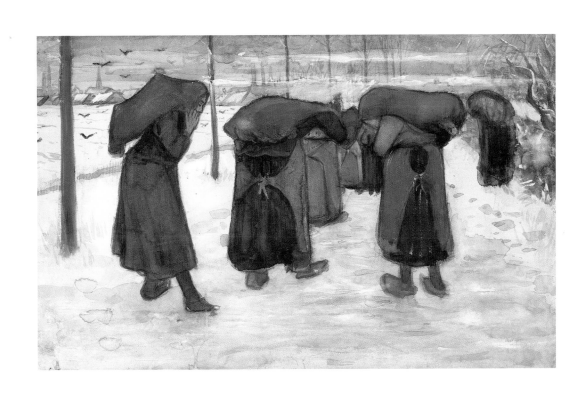

Weaver, Seen from the Front

1884
Oil on canvas, 64 × 80 cm
Otterlo, Kröller-Müller
Museum

In 1880, at the height of his disappointment at the outcome of his career as a preacher, Van Gogh walked almost seventy kilometers to Courrières on the Belgian–French border to meet the painter Jules Breton, a landscape artist of the Barbizon school, whom he particularly admired. Feeling uncomfortable at the orderly, bourgeois appearance of the artist's house he decided against meeting Breton, but his journey had an unexpected result. In the village he saw numerous weavers and was struck by the relationship between the large machines and the men who operated them. Over the years these early observations led to a long series of drawings and paintings.

After a period in The Hague, where he painted the miserable life of workers and the squalor of the suburbs where they lived, Vincent moved to his parents' home in Nuenen and devoted himself assiduously to drawing and painting farm laborers and weavers.

In a letter to Theo he expressed the appeal of the work he was doing: "These looms [...] are such splendid things, all that oak against a grayish wall. [...] I have seen them weave in the evening by lamplight, which creates effects that bring Rembrandt to mind" (letter to Theo 367, late April, 1884). Though the loom in the painting is seen by day, the influence of the great seventeenth-century Dutch artist is apparent in the brown and yellow harmony and the effects of the shadow seen in different parts of the machinery. In Vincent's vision, the machine does not represent the usual negative value of alienation at work. Here he sees a degree of positiveness in the union of man and machine, each being necessary to the other; in the painting the man is relegated to the background which makes the loom itself the protagonist of the scene.

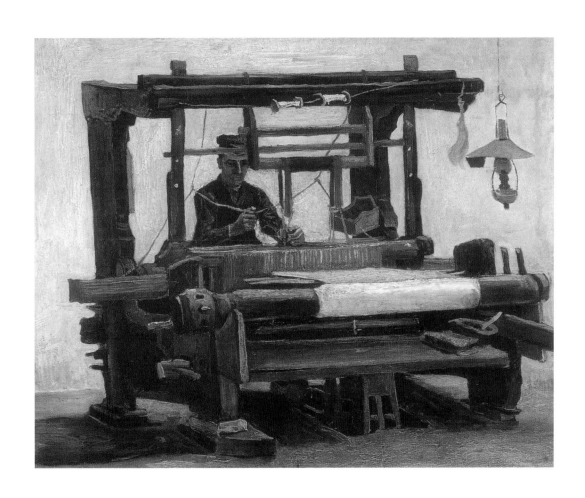

The Potato Eaters

1885
Oil on canvas, 82.5 × 114 cm
Amsterdam, Van Gogh
Museum

This was the most important painting from Van Gogh's Dutch period, before he moved to Paris. Although his palette later became lighter and more luminous and he produced less elaborate compositions, Vincent continued to consider this painting as one of his best works. In 1887 he wrote to his sister Wil that he thought it "the best thing I have done" (letter to Wil 1, autumn–winter, 1887) and he repeated the motif in several drawings he made in Saint-Rémy in 1890.

Depiction of rural workers was quite common in nineteenth-century painting in Holland and France but painters like Millet and Israëls gave them a romantic slant. Van Gogh turned his back completely on the idyll and created an image of great coarseness and realism.

The painting shows five people of different age sitting in a bare, narrow, pitiful shack. It represents a peasant family together during their evening meal. The flickering light of a lamp illuminates their bony faces and knotted hands, which are the outward signs of their daily toil. The figures appear isolated, they do not look at one another and the girl in the shade with her back to us is an expedient used by Van Gogh to distance and exclude us from the scene. The artist does not idealize the figures in any way and prefers to accentuate their coarseness with the use of dark, stained colors. In a letter to his brother, he explained he had wanted to underline how "these people eating potatoes by the light of their lamp have dug the earth with the self-same hands they are now putting into the dish, and it thus suggests manual labor and a meal honestly earned."

The Potato Eaters was for Vincent a manifesto of his artistic and social creed and, as such, was prepared for with myriad studies and compositional sketches. The artist dreamed of producing a "history painting" and even broke off his friendship with Anthon van Rappard, who had criticized the work and how the protagonists were posed.

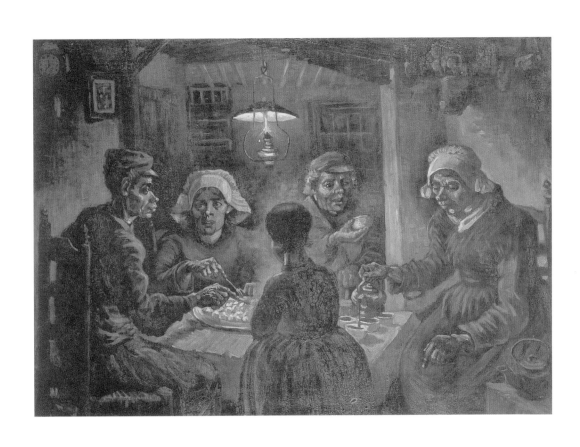

Landscape at Dusk

1885
Canvas on cardboard,
35 × 43 cm
Madrid, Museo Thyssen-
Bornemisza

This small landscape was painted in Nuenen, where Van Gogh was living at his parents' house after his father had been appointed to the presbytery there from the end of 1883 to 1885. The paintings he produced during this period embrace two principal subjects: portraits of peasants and landscapes. The artist loved the countryside and drew upon the glorious Dutch tradition of landscape painting, but he also gave it his own interpretation that followed on from the artists of the School of the Hague, which in turn had been inspired by the Barbizon school in France.

Here Vincent explicitly makes reference to those schools. The subject seems ordinary, even humdrum, and does not even have a significant building in it. Like the seventeenth-century landscape artist Jacob van Ruysdael, whom Vincent particularly admired, he did not choose a particular angle, just a simple view of the countryside. One of the most admired painters in the school at the Hague, Anton Mauve, was Van Gogh's master for a brief period and here we see that Vincent imitated the clarity of his vision and tonal harmonies—which accord with the local colors—without attempting to create any effect or "bravura piece."

The composition has great simplicity: the space is divided in two by the horizon and emphasized by the brown band of the field. The lower, darker section is dominated by the presence in the center of the snowy dike that introduces an element of luminosity. The upper half revolves around the clear tones of the sky, of which the white mass is balanced by the slender outlines of the trees. Standing asymmetrically on either side of the dike, they help to carefully organize the empty spaces. The appeal of the painting derives from its extreme simplicity.

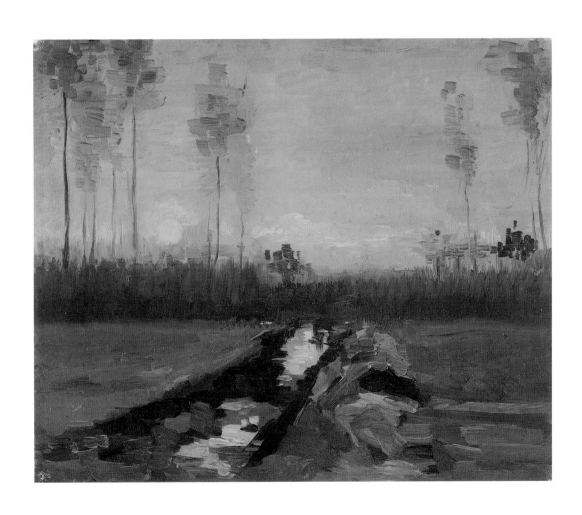

Still Life with Bible

1885
Oil on canvas, 65 × 78 cm
Amsterdam, Van Gogh
Museum

This painting was executed in Nuenen where Van Gogh lived with his parents from 1883 to 1885. His father was a Protestant minister in charge of the priorate of the city and the artist himself had experienced a period of intense religious fervor that, in 1876, had led him to resign from Goupil's, the art dealer. Vincent had then attended an evangelizing school and moved to the desolate region of the Borinage, in Belgium, to preach to the miners, but he had performed his work with such fanatical zeal that his appointment was not renewed. A critical period followed at the end of which Van Gogh chose to follow art as a profession. His attitude toward the church was affected and his indignation toward the hypocrisy of many of its representatives emerges in several of his letters. Relations with his father further deteriorated but, when the latter suddenly died in March 1885, Vincent was deeply upset.

Still Life with Bible was painted a month after this sad event and represents the artist's state of mind. The sacred text, which Vincent had begun to translate into four languages, lies gigantic on the desk. Next to it is an extinguished candle, the symbol of meditation, which used to allude to the theme of memento mori in the painting of past centuries. In the foreground, Vincent has included a modern novel, *La joie de vivre* (*The Joy of Living*) by Émile Zola, one of the artist's favorite authors.

The apparently simple painting brings together themes that were crucial to the painter: a meditation on death linked to that of his father, the importance of religion in the life of the two men and, at the same time, his encounter with a different field of interest: "modern life" that was the object of discussion, description, and representation by the most progressive exponents of art and contemporary culture.

Vase with Hollyhocks

1886
Oil on canvas, 91 × 50.5 cm
Zurich, Kunsthaus

Once he moved to his brother's house in Paris in 1886 Vincent began painting a series of vases of flowers. During his earlier movements around Holland, he had produced several still lifes mainly based on shoes. Since the early 1880s he had become interested in the theory of color propounded by Eugène Delacroix and in Paris he was particularly struck by the works of Adolphe Monticelli and his skills as a colorist. Monticelli's many paintings of flowers prompted Van Gogh to follow suit and this one in Zurich is one of many examples. The influence of impressionism is not yet seen as at first Vincent was not drawn to it. Compared to the charged, though traditional, palette of Monticelli, the much paler and more luminous tones used by Monet and his companions must have appeared insipid to him.

To the eyes of the modern observer, *Vase with Hollyhocks* appears sober chromatically, even faded. The red of the taller spray is dark, as is the green of the leaves that hang down the side of the vase. Even the vase itself, which varies from gray to brown to black, gives the whole a feeling of heaviness despite the presence of the white flower and buds, and, above all, of the luminous yellowish–green background.

The Restaurant de la Sirène at Asnières

1887
Oil on canvas, 54 × 65 cm
Paris, Musée d'Orsay

After Van Gogh had completed the lessons he took in Cormon's studio and, in particular, his visits to the paint shop belonging to Père Tanguy, who sympathized greatly with young artists, he met and made friends with Émile Bernard and Paul Signac, two painters that were to become two of the most important exponents respectively of symbolism and neoimpressionism.

In the warm weather the three often went to paint outdoors in Asnières, a suburb of Paris on the banks of the Seine that had earlier inspired Monet and Pissarro. Vincent took on the challenge of one of the subjects typical of the "painters of modern life," choosing a social setting at a quiet moment. The atmosphere suggests it is a Sunday afternoon, something that Renoir and colleagues had painted many times. Though claiming not to be part of the impressionist group, Van Gogh was stimulated by their choice of light colors and impressionist brushwork. This painting revolves around the harmony of the lighter colors—yellow, blue, and pink—with the red of the wall, door, and other details that he employed to brighten the painting up. Black is reduced to the minimum and the artist makes use of colored shadows which was one of impressionism's greatest innovations. Every tint is reflected on its surrounding environment and consequently even the shaded areas are not completely dark.

The representation of the restaurant in the title is a pretext to show, from an unusual angle, a view of a suburban street and to experiment with the new pictorial techniques that Van Gogh was discovering in Paris, the world capital of art in the nineteenth and earlier twentieth centuries.

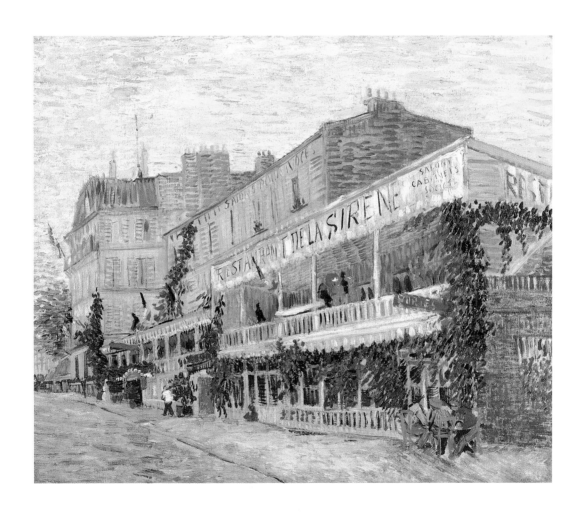

A Pair of Shoes

1887
Oil on canvas, 34 × 41.5 cm
Baltimore, The Baltimore
Museum of Art

At the start of his career Van Gogh had several times attempted still lifes of shoes. The reasons for his choice were, first, that it was a relatively simple subject that offered the artist (not yet sure of his technique) the possibility to practice, and second, it meant he did not have to find models. This was not easy for him due to his financial difficulties, and more than once he complained to his brother of the difficulty he had in paying those people who posed for him.

The painting in Baltimore was executed in Paris a few months after he moved to the city. Despite the apparent banality of the subject, the work shows how much attention Van Gogh devoted to the developments in contemporary painting. The composition is given a degree of dynamism by the diagonal slant of the table top and further enlivened by the rapid brushstrokes used to represent the blue cloth that seems almost to slide under the boots. Already impressed by the freedom of touch used by the romantic painters Delacroix and Monticelli, Van Gogh also began to study the work of the impressionists, with their luminous colors and the dynamic, non-frontal angles with which they viewed their subjects. Compared to his Dutch period, his choice of colors is lighter: he has paired a light brown with the blue and touches of white appear here and there to brighten the surface. He paid careful attention to the light, which he used to invest the surfaces with movement and highlight certain details, for example, the twisted laces, the worn leather and the thickness of the nails on the sole.

The black background, which forms a series of rectangles and squares, seems to have been painted using a thin brush tip in a manner that brings to mind etchings. Here Vincent was drawing on his experience as a draughtsman and his passion for graphical work, on which he had concentrated during his stay in The Hague when he had planned to earn a living as an illustrator.

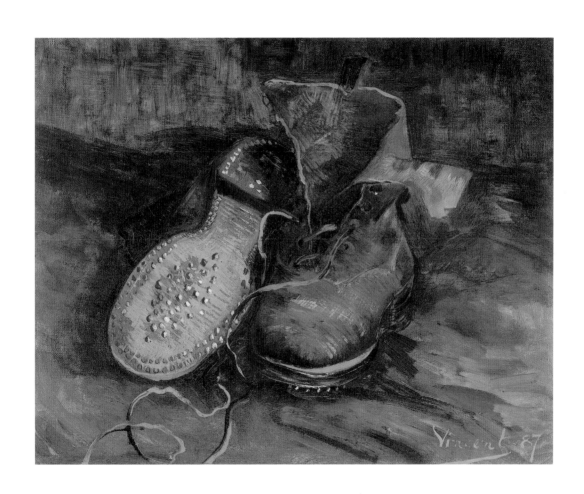

Sunflowers

1887

Oil on canvas, 43.2 × 61 cm
New York, The Metropolitan
Museum of Art

During the years he spent in Paris, direct study of paintings enabled Vincent to deepen his understanding of the use of color that his reading of the theories of Delacroix had begun to instill in him. The impressionists had completely revolutionized the nineteenth-century palette by introducing the custom of painting on a white background with pale, light-filled colors. Japanese prints that Vincent had collected for some time offered him examples of combinations of vivid complementary colors and maintained the use of black, something the impressionists had done away with.

Fascinated by the works of Adolphe Monticelli, Vincent had initially painted a long series of still lifes of vases of flowers. The two sunflowers in the Metropolitan Museum represent a completely different conception: Van Gogh chose to depict just the heads of the flowers close up against a blue background. The result is one of great freshness created by a combination of already existing ideas: on the one hand, his still lifes had shifted from shoes to sunflowers though there are similarities in the angle from which they are viewed, the use of an indefinite monochrome ground and the placement of one directly facing the observer and the other face down. On the other hand, he made reference to Japanese prints: several examples by Hokusai (one of the favorite artists of the lovers of Japonisme) are similar in composition, with flowers and leaves shown against monochrome backdrops. Also drawing on oriental graphics, Van Gogh reintroduced black, thereby creating "graphical" effects in the changeable forms of the petals which he painted individually, and in the dark lines inside the flowers which he created using the wooden tip of the brush.

This painting is a demonstration of how Vincent had by then absorbed various artistic languages and mastered them, combining them to suit his purpose and create new and personal images.

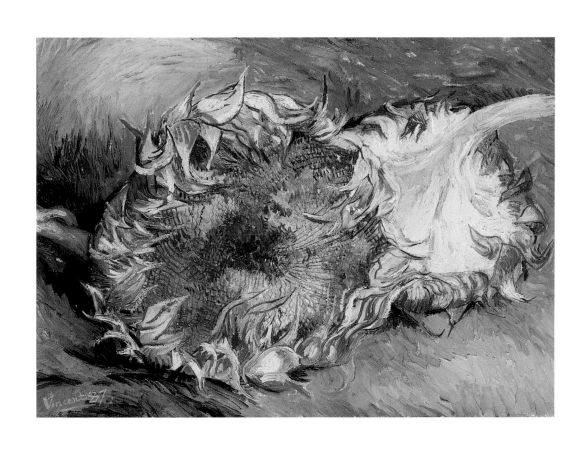

Japonaiserie: Oiran

1887
Oil on canvas, 105.5 × 60.5 cm
Amsterdam, Van Gogh
Museum

When Japan opened up to the West in the 1850s, the result was an invasion of eastern art into Europe. The absolute novelty of the subjects and style combined with their aura of exoticism gave rise to a fashion and cultural phenomenon that came to be called Japonisme. The most avant-garde European painters, beginning with the impressionists, began to collect prints by Hiroshige and Utamaro and to use them to inspire their own rigorously two-dimensional decorative images placed against a diagonal setting as opposed to the traditional frontal views. Manet, Degas and Monet were among the first to use these characteristics in their own paintings and experimented with the new so-called *Japonaiserie*.

Van Gogh had begun to admire Japanese prints while he was living in Holland and purchased some in Antwerp toward the end of 1885. At first he did not use them to change his own style but his interest grew enormously once he moved to Paris where he even organized an exhibition of his collection. He produced a large painting taking as inspiration a figure in a kimono by Kesai Eisen printed on the cover of "Paris Illustré." He created a pastiche by placing Eisen's figure like a poster in the middle of a decorative background. The reed grove behind was conceived as a *divertissement*, with a rowing boat on the river "above the geisha's head," while she is "supported" beneath by a yellowish frog, which Van Gogh took from Yoshimaru's *New Prints of Reptiles and Insects*.

Vincent became a devotee of Japanese art to the point that Bing, who represented a reference point for anyone wishing to buy oriental art, allowed him to wander freely around his store, and even through his storeroom. For Vincent, Japan came to represent a Utopian world, unspoiled and paradisiacal. When he left for Provence, he referred to the south of France as a "European Japan."

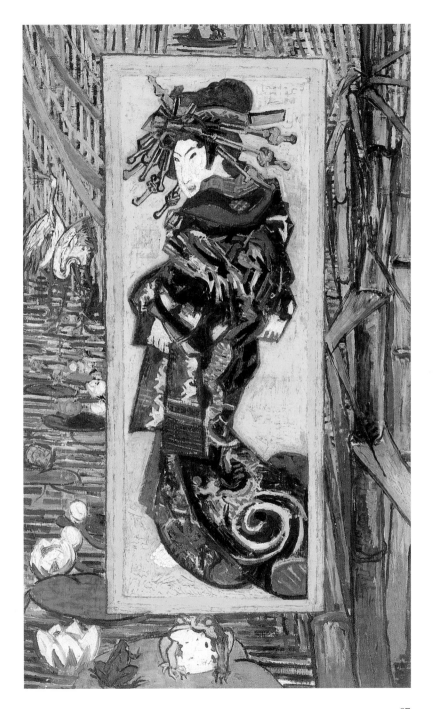

Italian Woman
(Agostina Segatori?)

1887
Oil on canvas, 81 × 60 cm
Paris, Musée d'Orsay

In 1887 Van Gogh organized an exhibition of Japanese prints at the Café Le Tambourin belonging to Agostina Segatori, a woman who had modeled for Degas. Vincent had a brief relationship with her and it is probable that the woman in this painting is indeed Segatori. Here Vincent seems to continue the line of "types" that he had begun in Brabant as though he had wanted to portray the epitome of Italianness. The woman is dressed in a folkloric costume indicated by the handkerchief on her head, her folded apron, and red cuffs; she holds two field flowers alluding to rustic life. In contrast to what Van Gogh had done in Holland, where he complained that the peasants asked to pose in their Sunday best, he has not portrayed the woman in her work clothes. Her dress is an explosion of color and the surface of the skirt a kaleidoscope.

The painting includes various pictorial influences: there is a slight reference to impressionism in the representation of her skin as a living surface that reflects light and the contiguous colors, but the major influences are pointillism and Japanese prints. Both demonstrated to Vincent that pure colors could be placed beside one another to create greater luminosity in the surfaces, which here seem to be almost enameled. Vincent's friends Signac and Seurat, who championed neoimpressionism, generally gave their paintings a dotted border, the colors of which reflected the chromatic trend of the painting itself. It was this trend that Vincent followed here in his fringed borders. However, the extreme freedom of the two borders reveals the influence of Japanese prints, which Van Gogh admired so much.

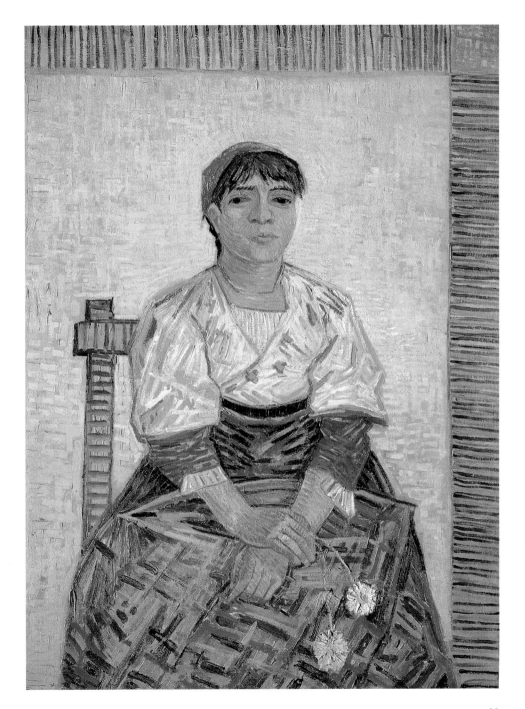

Portrait of Père Tanguy

1887–1888
Oil on canvas, 65 × 51 cm
Paris, Stavros S. Niarchos
Collection

Julien Tanguy was an elderly paint seller nicknamed "père" (father) by young Parisian artists due to his age. He had fought for the Paris Commune and had also been imprisoned. Tanguy acted on his ideal of creating a better world by helping penniless young artists, accepting their canvases in return for materials, offering them credit, and even sharing his humble meals. For a long time he was the only person to exhibit the canvases of Van Gogh and Paul Cézanne. It was through Père Tanguy that Van Gogh met the neoimpressionist Paul Signac and struck up one of the longest-lasting friendships of his life, namely with the symbolist painter Émile Bernard. Tanguy also turned out to be a real friend to Vincent and went to Auvers for his funeral.

Van Gogh made two portraits of Père Tanguy, in both cases composing a background of several of his and Theo's Japanese prints, today exhibited in the Van Gogh Museum in Amsterdam. Tanguy himself is depicted in a pose characteristic of Asian art manner, like a dark silhouette that stands out against the decorative backdrop. The absence of spatial cues removes any distraction and the gaze focuses entirely on the figure of Tanguy, who is shown by Vincent as both very present and human, almost moving. The man is seated and wears a hat and buttoned jacket. His large, rough hands are folded on his lap and his serious expression has a look that appears slightly lost. The artist has not idealized the old fighter, preferring to concentrate on the psychological reality of the sitter, whose expression reveals the goodness of his heart. Van Gogh has given us a contemplative portrait but his style is still somewhat hesitant though he had already given up impressionist brushwork in favor of a more energetic and penetrating touch in order to create an image charged with emotionalism.

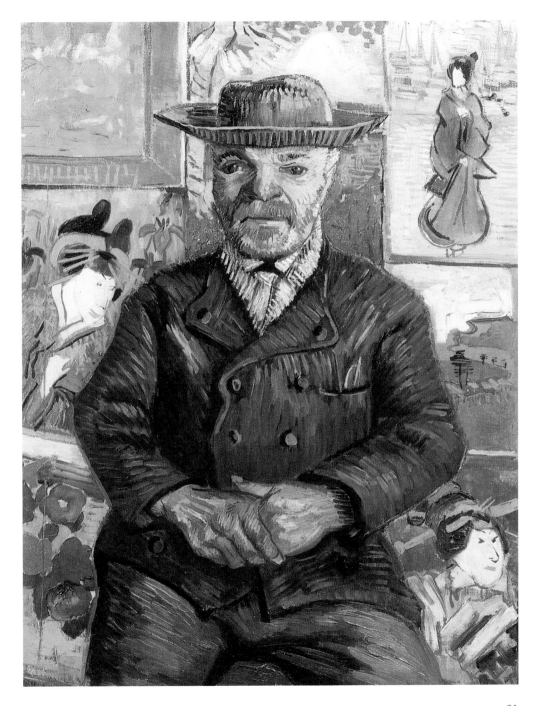

La Mousmé

1888
Oil on canvas, 74 × 60 cm
Washington, D.C., National
Gallery of Art

This painting is of a young girl from Arles who was nicknamed by the artist *La Mousmé* from the name of a character in the story *Madame Crysanthème* by Pierre Loti. Van Gogh enjoyed painting portraits and at the end of his life, portraiture came to be his principal interest.

The approach is traditional with the model posing against a monochrome background created by short, thick orthogonal brushstrokes to give a woven appearance. The girl is shown in three-quarter profile with her figure crossing the pictorial surface diagonally. She looks pensively and hesitantly at the artist and holds an almond or peach blossom in her hand, something that Vincent had painted many versions of. The artist uses the girl's clothing as a pretext for decorative patterns, for instance, the long line of red buttons on her striped jacket extends the cloud of large dots on her skirt that seem to float on the dark sea of material.

As he had experimented with on other occasions, Van Gogh restricts his palette to a few, carefully calculated and alternated colors. The green backdrop stands out against the dominant red of the girl's clothing which is in turn contrasted with the black and white details and the pink of her face and tapering hands. The dark curved seat encircles the girl with ornamental arcs set against the pale backdrop and closes off the otherwise empty space on the right.

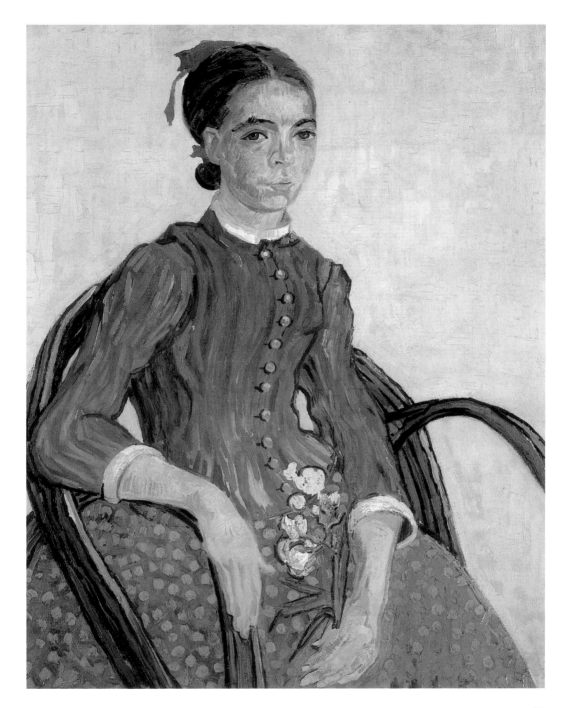

The Sower

1888
Oil on canvas, 64 × 80.5 cm
Otterlo, Kröller-Müller
Museum

Farming subjects were one of Van Gogh's main interests throughout his artistic career. As a young man he had worked as an assistant in various branches of the Goupil art gallery, which specialized in nineteenth-century French and Dutch landscapes and in the sale of reproductions of works of art. This enabled Vincent to become familiar with the works of Jean-François Millet who, more than anyone else, had celebrated the rhythms of rustic life and visually transformed working in the fields into a moment of communion between man and nature. Millet was always one of Vincent's favorite artists and on several occasions the Dutch artist had copied his works, varying and remaking them. The figure of the sower was in particular one of Van Gogh's favorites, partly due to the strong symbolism of the man alone in the midst of nature, and his actions as the bringer of life.

The Otterlo painting depends entirely on colors. It was painted in Provence where he had gone in search of stronger light and more vivid colors: in his imagination the south represented a sort of unspoiled paradise. The canvas is dominated by two complementary tints: the violet of the field and figure and the yellow of the sky and ears of corn. The sower's clothes have the same tones as the nature that surrounds him in order to identify him implicitly with that nature. He does not, however, stand at the center of the painting which is instead occupied by the almost dazzling ball of the sun. The direction of the brushstrokes follows the sun's rays and even the field has a slightly curving tendency as though the sun was unleashing a beneficial, vivifying force that affects everything.

The image of the sun—which, since antiquity has been a positive metaphor—was often used by the symbolists, including the Italian Pellizza da Volpedo. Even though Van Gogh did not often paint the sun, yellow was the color he preferred to use.

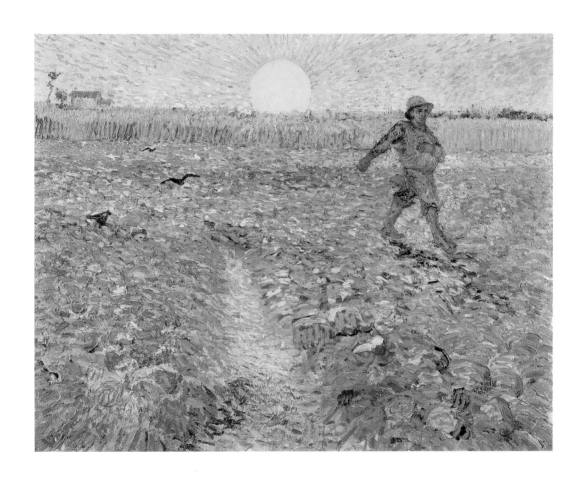

Twelve Sunflowers in a Vase

1888
Oil on canvas, 91 × 72 cm
Munich, Neue Pinakothek

Sunflowers are one of the most famous of Van Gogh's subjects as well as being one of his favorites. He made more than ten versions of them during his period in Arles. Using them he developed a completely new idea of still life, transforming it on the one hand into a decorative element and, on the other, into an energy-filled "natural-life," if the pun is permitted.

Vincent had begun to paint vases of flowers under the influence of the works of Adolphe Monticelli, an artist close to the style of Delacroix, whose vivid, fresh colors were transformed into a sort of eternal, pregnant image very different to the transience of traditional still lifes. Van Gogh also resorted to studying Japanese prints, from which he had learned the use of flat, two-dimensional expanses of color that turn forms into silhouettes. The brown line around the vase and between the wall and the table or floor has just that function of making the masses light and turning them almost into elements of a collage. The manner in which he has represented the flowers is different: whereas he has used broad, straight brushstrokes in the vase and background, the sunflowers have been rendered using more mobile brushwork that follows the directions of the petals and leaves. The flowers are thus permeated with personality and dynamism, taking on a symbolic value and acting as a metaphor for the vitality of nature.

The painting revolves around the harmony of two colors, the green of the leaves and (in a slightly lighter tone) of the background, and the yellow of the horizontal surface, the vase and the flowers. The result is a lively, joyous image. Vincent conceived this series of canvases as a decoration for his "studio in the south," the workshop he planned to share with Paul Gauguin which was to create a new and powerful art.

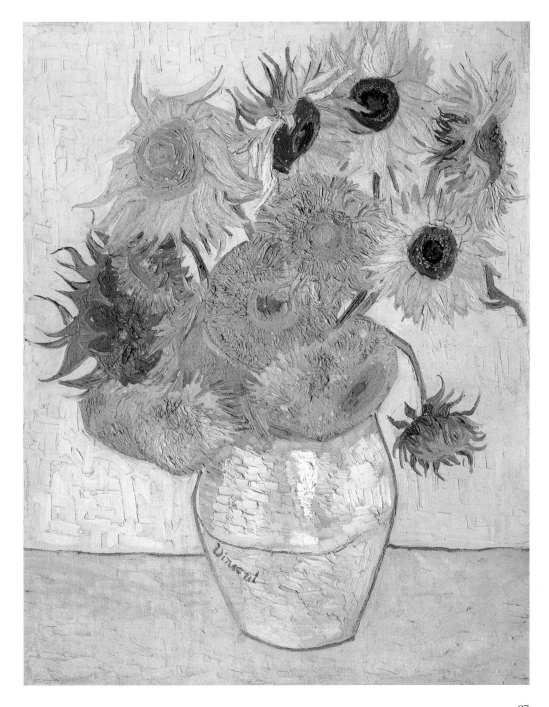

Willows at Sunset

1888
Oil on canvas applied on
cardboard, 31.5 × 34.5 cm
Otterlo, Kröller-Müller
Museum

Vincent painted this work in Provence in autumn 1888 and created an image of extraordinary power and great emotional impact. A blue band at the center—against which stand the brown outlines of the willows, simplified to a few lines—divides the sky from the field, creating two colorful areas charged with warm reds, oranges and yellows. As in *The Sower* in the same museum, the sun is a ball of energy from which long streaks of color radiate. To balance the power of this sky, the artist has dedicated a large space to the tall, dry grass in the foreground. It is almost as though we are lying in the grass looking toward the horizon. Between the earth and the sky stand the profiles of three bare willows at even intervals in a diagonal line. Their bare branches stretch upward to be cut off at the edge of the canvas. Using chiaroscuro and alternating warm and cool—though colorful—tones, Van Gogh gives substance to a potent vision. The masses are synthesized to the maximum, and the long brushstrokes generate a grid of lines between the eye of the observer and the background. The painter was enjoying a period of great happiness and creativity and wrote to his brother Theo that he was in "a feverish state" in which he was painting incessantly, not stopping even to eat. His personal style was in strong evolution and he wrote that "I have deliberately arrived at the point where I will not draw a picture with charcoal. That's no use, you must attack drawing with the color itself in order to draw well" (letter to Theo 539, September, 1888).

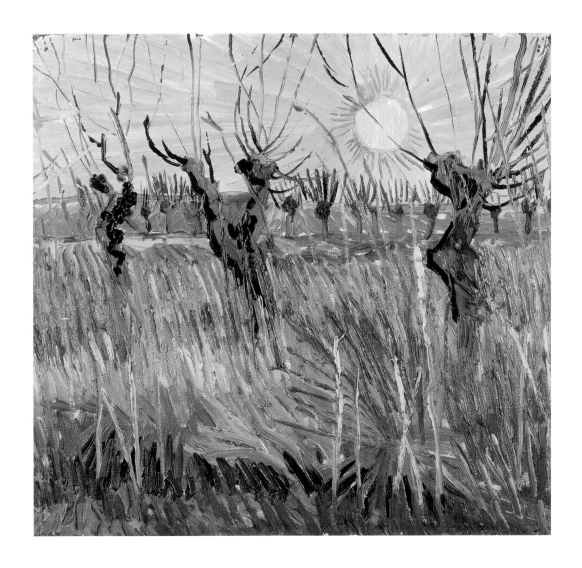

Portrait of the Postman Joseph Roulin

1888
Oil on canvas, 81.2 × 65.3 cm
Boston, Museum of Fine Arts

The postman Joseph Roulin was one of Van Gogh's best friends in Arles and one of the most loyal of his life. He went to visit Vincent at the hospital every day following the episode in which the artist cut off his ear; he accompanied Vincent home once his stay in the hospital was over. The artist portrayed Roulin several times and other members of his family, as well giving the paintings to them as gifts. Roulin was an imposing man, roughly two meters tall, who worked for the postal services in the French railways. Describing his friend to Theo, Van Gogh compared him to Père Tanguy saying that they were both ferocious opponents of the Third Republic, imbuing Roulin with the air of a revolutionary.

The postman is portrayed in uniform, gazing directly at the viewer with a serious expression. Van Gogh was experimenting with the use of a restricted range of colors in which large flat surfaces are enclosed by strong outlines in the manner Vincent learned from looking at Japanese prints. This painting employs several techniques the artist had already used in *La Mousmé*, such as the monochrome background composed of perpendicular hatching and the seat with the curved back. However, on this occasion they are treated more summarily and Vincent eliminated all secondary details in order to concentrate on the large colored surfaces. The different sections of Roulin's uniform—the collar, sleeves, trimming of the jacket—are delineated with thick black lines whereas the man's pink skin is enlivened with red and blue touches that are mirrored in his thick beard.

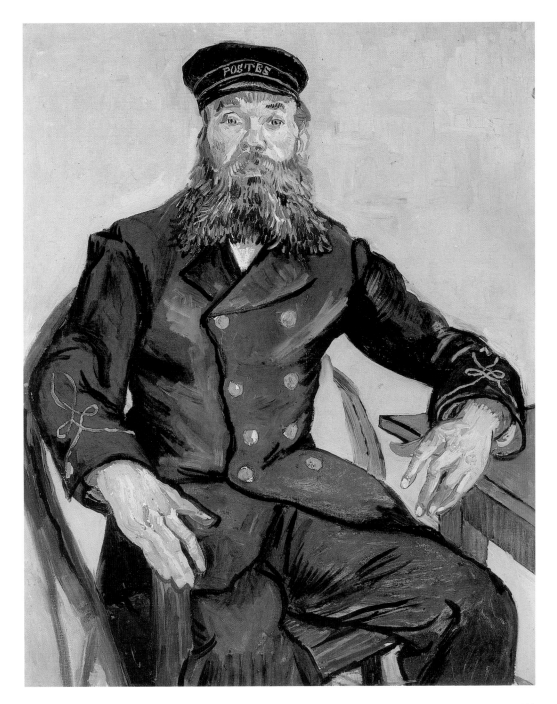

101

Portrait of Eugène Boch

1888
Oil on canvas, 60 × 45 cm
Paris, Musée d'Orsay

Eugène Boch was a Belgian painter and writer that Vincent met in Arles. His bony, triangular face, pronounced nose and receding hairline was very similar to reality (as we know from a photograph), but Vincent gave his version a symbolic interpretation. The ocher outline around the figure makes Boch seem like a colored shadow in front of a dark blue background, perhaps a sort of ancient icon. Vincent was very interested in Japanese prints and it was they which inspired the two-dimensional definition of the portrait. The night sky, dotted with stars, creates an evocative atmosphere accentuated by the ocher circle, rather like a halo, around Boch's head. Van Gogh explained that he wanted to paint "I want to paint men and women with that something of the eternal which the halo used to symbolize, and which we seek to confer by the actual radiance and vibration of our colorings" (letter to Theo 531, September 3, 1888).

The painting is constructed around a series of parallels dictated by the use of a narrow range of tones: the ocher dominates both the man's jacket and face alternated with a pale, bright green seen in the shirt, more expressive features of the face and the small star at the top left of the painting. The figure has been painted almost entirely using warm colors and appears like a sort of flame against the cold blue of the sky. This strange vitality is enhanced by Boch's gazing into space and melancholic expression accentuated by the brushstrokes that follow the structure of the bones of the man's face.

Vincent was fascinated by Boch who reminded him of a Flemish gentleman from the age of William the Taciturn. He made another portrait of him called *The Poet against a Starry Night* but this did not satisfy him and he painted *Jesus and the Angel in the Garden at Gethsemane* over it.

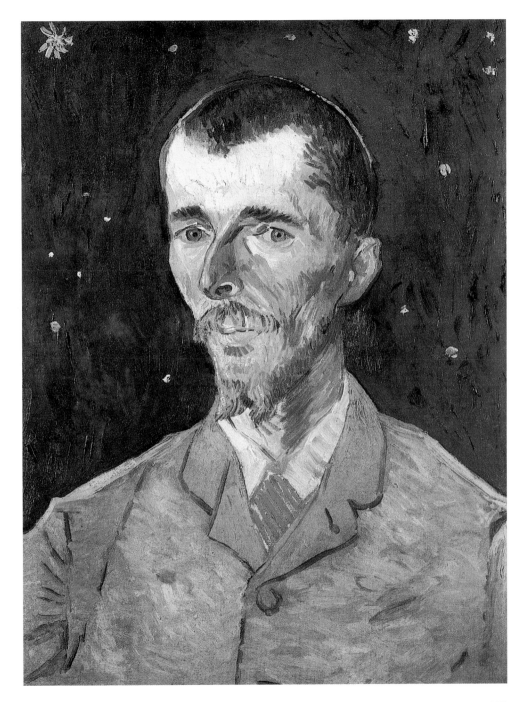

Portrait of Milliet, Second Lieutenant of the Zouaves

1888
Oil on canvas, 60 × 49 cm
Otterlo, Kröller-Müller
Museum

The second lieutenant of the zouave regiment, Paul-Eugène Milliet, was one of the individuals Van Gogh befriended in Arles while the soldier was on leave after having fought in the Battle of Tonkin. Milliet was an amateur artist and took several drawing lessons under Van Gogh, though he refused to learn to paint with him because he disapproved of the artist's methods: "He paints too freely, without paying attention to details and without making sketches […] He replaced drawing with colors." Milliet described his new friend as "a strange sort […] impulsive and bizarre like someone who had spent a long time under the baking desert sun […] who became abnormal every time he picked up a brush" (quoted in J. Rewald, *Post-Impressionism from Van Gogh to Gauguin*, Museum of Modern Art, New York, 1956).

The zouave is shown half-length against a blue background painted more freely than in the portraits of *La Mousmé* and *Joseph Roulin*. Milliet, too, is painted wearing his uniform, which is adorned with a medal for valor pinned to the front. Van Gogh concentrated on the man's face, focusing his attention on his eyebrows, beard, long reddish moustache, small but prominent ears, and nose. The cap worn at an angle gives him a harried look that matches his resolute gaze and frowning expression. In the top-right corner of the painting Van Gogh has added the hammer and sickle. The artist was fascinated by Milliet's accounts of Indochina, as was Gauguin, who continued to hope to find the money for a new trip to Martinique, then thought he might go for a certain period to Tonkin instead.

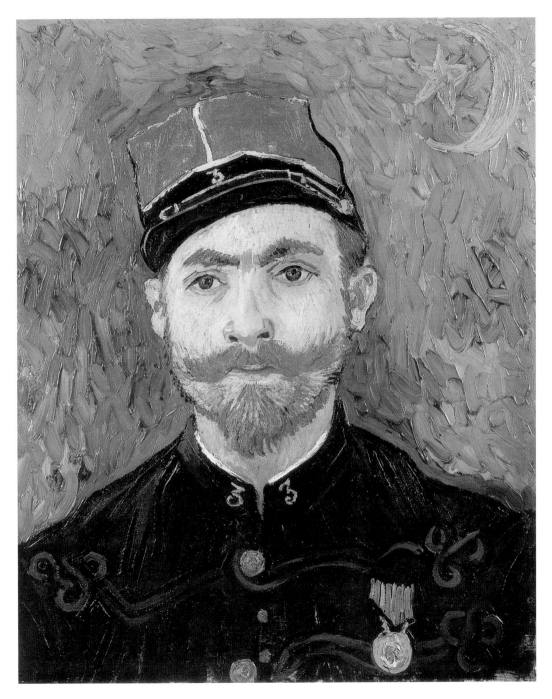

Café Terrace at Night

1888
Oil on canvas, 81 × 65.5 cm
Otterlo, Kröller-Müller
Museum

This is one of Van Gogh's most famous works and one of several paintings he made of the café in Arles from different viewpoints. Bars and cafés were one of the favorite subjects of impressionist and pointillist painters in their function as meeting places and instances of "modern life." Vincent's work, however, takes a different slant: what he is interested in is not the emotions of the customers but the nighttime view.

In this period he was particularly fascinated by painting the dark starry sky, as is seen in several of his greatest works. This one is characterized by the contrasts between the dark surfaces of the sky and buildings and the bright yellow of the café lit by lamps. What makes the image particularly successful and attractive is the long perspective view. The foreground opens to the observer and we are given the impression that we are walking down the cobbled street; the dark jamb of an entrance cut off by the edge of the painting closes our view on the left and leads the eye to the café's covered terrace. This is emphasized by the three lines of round green tables. The right side of the painting is occupied by a view of the street lined by dark houses and lighted windows. Vincent's use of the same colors in the interiors creates a pleasing balance: the pale green of the table-tops in the café is repeated in the clothes of the woman standing at the center of the painting, while the yellow–blue contrast in the buildings is also seen in the starry sky. Like other paintings of the same period, Van Gogh painted some details tone-on-tone, like the yellow wall lamp seen against the similarly colored wall of the café. The scene is completed by figures chatting in the street or at the tables on the terrace who help to make the setting cheerful and busy.

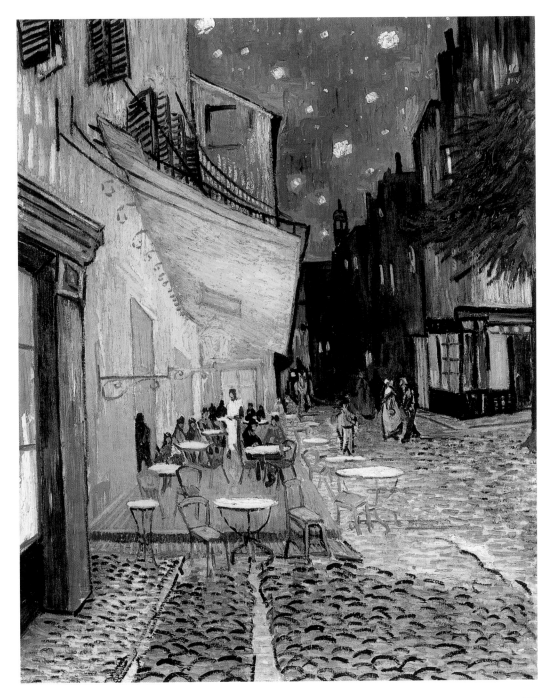

The Night Café

1888
Oil on canvas, 70 × 89 cm
New Haven, Yale University
Art Gallery

Van Gogh was proud of this painting which, with *The Potato Eaters*, he considered one of his best works. It shows the interior of the café owned by Madame Ginoux, the woman portrayed as *L'Arlésienne*. Vincent described it carefully: "I have tried to express the terrible passions of humanity by means of red and green. […] Everywhere there is a clash and contrast of the most alien reds and greens. […] It is color not locally true from the point of view of the *trompe l'œil* realist, but color to suggest some emotion of an ardent temperament" (letter to Theo 533, September 8, 1888). And he added, "I tried to show that the café is a place where people can ruin themselves, go crazy or commit a crime" (letter to Theo 534, first half of September, 1888).

The space seems unstable and almost hallucinatory as though it and everything in it were about to slide toward the observer. The figures are relegated to the sides, no one is serving or clearing the tables. The figures themselves appear isolated and their relations seem anything but cordial. The attitudes of the pair in the background are certainly not those of a couple of lovers and on the contrary give an impression of brutality. If the billiard table that throws a disquieting shadow is excepted, the center of the scene is empty and a sense of abandon dominates. The vivid and strident colors transmit a feeling of violence.

Underlying the definition of the scene there is a notable culture: the multiplication of space through the two doors in the background and the mirror on the right hark back to seventeenth- or even fifteenth-century Flemish painting. The café environment, moreover, was one of the favorite subjects of the impressionists and pointillists and Van Gogh shows himself to be anything but isolated. He offers a very personal interpretation of one of the most common themes of the painting of the age.

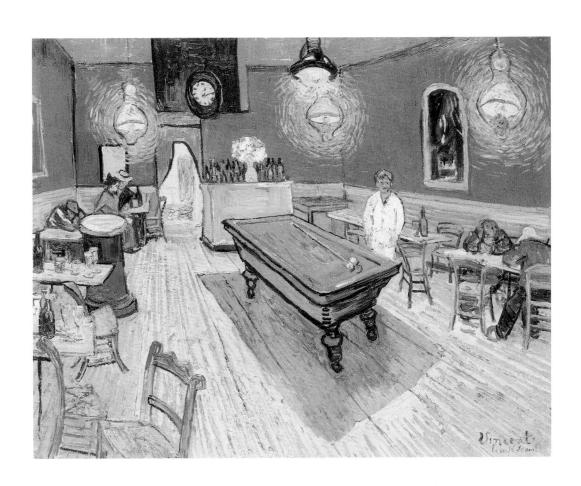

Les Alyscamps, Falling Autumn Leaves

1888
Oil on canvas, 73 × 92 cm
Otterlo, Kröller-Müller
Museum

Les Alyscamps was an avenue in Arles where Van Gogh often went to paint with Gauguin in autumn 1888. In this work he once again drew on artistic expedients seen in Japanese prints: the street is depicted from an unusual viewpoint, with a diagonal perspective accentuated by the partially visible rise on the right and the rows of benches on either side of the avenue. Even the tapering tree trunks that separate the street from the surrounding scenery emphasize the perspective. Together the benches and trees are rhythmical elements that accompany our reading of the image. Their flat, Japanese-style silhouettes are cut off by the top of the canvas and therefore also become ornamental features. The figures walking down the avenue are little more than decorative silhouettes, and that of the man has been left as a sketch with the bottom of his body just dashed in.

The innovative angling of the painting, its perspective, and the clear contrast of vertical and diagonal lines, is accompanied by an equally energetic use of color. Van Gogh has set down a series of masses of strong, contrasting colors in a completely two-dimensional definition, playing on the harmony of the warm and cold sections of the painting: the dominant red of the avenue—flanked by the brown of the side of the hill—alternates with the blues and greens of the trees and benches and the monochrome and unreal view that opens on the left side of the painting. This vigorous, incisive work reveals most strongly the influence of Japanese art.

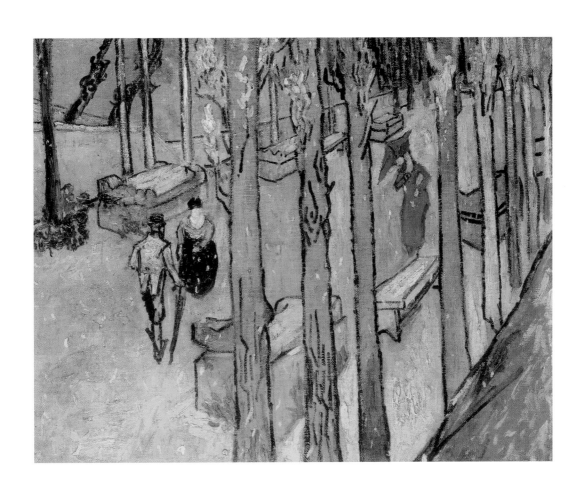

The Yellow House

1888
Oil on canvas, 76 × 94 cm
Amsterdam, Van Gogh
Museum

Van Gogh rented the Yellow House in Arles, while waiting for Gauguin to arrive, with the hope that it might become the "studio of the south," the seat of a community of avant-garde painters. Despite it being a fairly simple building—in fact the zouave Milliet was unable to understand how it could be the central feature of a painting—in Van Gogh's opinion the house acquired personality. The green shutters conspicuous against the yellow plaster almost appear to be eyes in a human face. The block on which the house stood is viewed from the corner; it is bounded on the right by an avenue which, passing beneath the railway, led out of the city. On the extreme left we see Place Lamartine, the location of the café Van Gogh frequently depicted.

The painting is a symphony in yellow, the artist's favorite color during this period and a symbol of the sunniness of Southern France. With the exception of certain pale green facades, the trees at the edge of the square and the pink awning next to the house, the painting revolves entirely around a series of pale yellows opposed by the intense blue band of sky. The road itself and the heaps of earth thrown up from the holes dug in the road are also yellow. The piles of earth have a precise visual function: lying in parallel along two diagonals, they indicate the axes that guide the observer in a reading of the picture. The general tone is of the middle of the day with the sun at its height, but Van Gogh has inserted various figures around the buildings to animate the scene. On the horizon in the distance a train crosses the railway bridge. The locomotive's white smoke is reminiscent of a subject much loved by the impressionists and represented by Monet in a series of paintings.

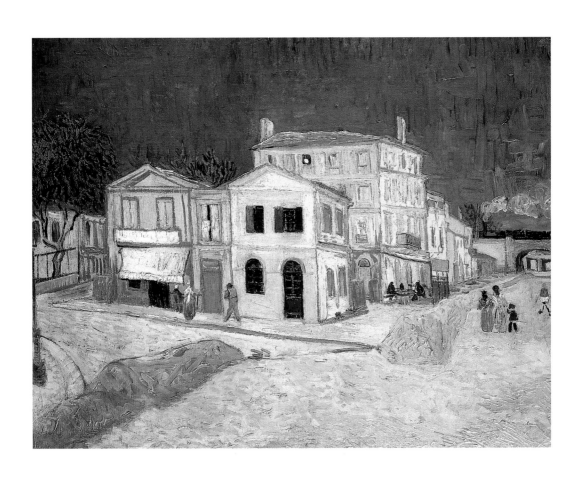

Vincent's Bedroom

1888
Oil on canvas, 72 × 90 cm
Amsterdam, Van Gogh
Museum

As he did on several occasions, Vincent produced different versions of the famous painting that showed his bedroom in the Yellow House. Perhaps more than even his self-portraits, this painting reveals the artist's private side. Like all the paintings he produced in Arles, the colors are used subjectively as, to the artist's mind, they are all symbolic. He also resorted to simplifying the forms, an expedient he had learned from Japanese prints which he explicitly stated to have taken as models for the painting. Describing it to his brother Theo, he said that since "simplification [gives] a grander style to things, here it is to be suggestive of *rest* or of sleep in general. In a word, looking at the picture ought to rest the brain, or rather the imagination" (letter to Theo 554, October 16, 1888). Unlike other paintings, such as the *Night Café*, the artist chose light colors and the principal harmony of ocher and blue certainly has a reassuring effect on the observer. The space seems to welcome us and to be a place of silence and meditation. All the objects—the seats, table, and paintings on the wall—face inward, giving the idea of a protected space, though the half-closed window at the far end and the two doors at the sides remove any risk of perceptive claustrophobia. The colors were also applied smoothly, without thick, heavy brushwork or the short, dynamic strokes that are characteristic of his art. In this picture Vincent has depicted a happy island, a domestic, ordered and harmonious ideal that may have described his personal wishes but certainly not his inclinations. Few personal objects—the paintings and towels hanging on the walls, the pink blanket and the jug on the table—help to make the room seem characteristic of its occupant, a place filled with a peace that the artist knew so rarely in his life.

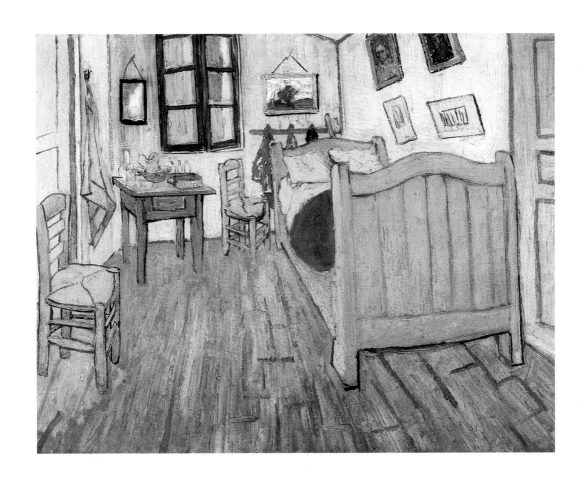

Vincent's Chair

1888
Oil on canvas, 93 × 73.5 cm
London, National Gallery

This painting was conceived with another, *Gauguin's Armchair*, during the latter's stay in Arles when the idea of the "studio in the south" seemed possible. Before moving to Provence, Gauguin had worked with Émile Bernard in Pont-Aven in Brittany where the two had made portraits of one another. In Provence, instead of painting his friend, Van Gogh chose to depict "his empty place" and then did the same for himself. The idea came to him from the memory of a painting by the Englishman Luke Fildes, who had painted, as an illustrated epitaph, the seat left empty by the death of Charles Dickens, an author greatly liked by Van Gogh.

For his own seat, Vincent chose a delicate, pale set of colors, focusing on three: the orange of the floor tiles, the yellow of the seat, and the turquoise of the walls. This harmony of colors was similar to those he had used some months earlier in *Vincent's Bedroom*. Facing the observer at a diagonal, the seat is seen close up, as though it were a portrait. Though apparently bare, the space is strongly characterized by two objects that substitute the artist: his beloved pipe and tobacco, shown clearly visible, and, in a basket on the ground, several sunflowers, which, during that period, were one of Van Gogh's favorite subjects. The artist's signature is deliberately placed just beneath these and, as usual, is given with just his first name.

In this way the painting is charged with the presence of the painter; like the painting of his bedroom, it gives an impression of great serenity. Indeed, Vincent was enjoying a period of relative joy even though very soon the situation would reach the tragic episode when he cut off his ear, which brought about the collapse of his dream of a shared life of art.

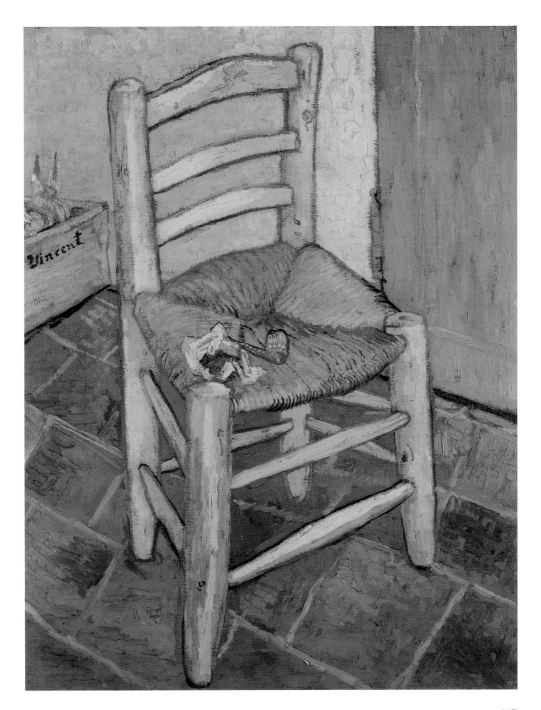

Gauguin's Armchair

1888
Oil on canvas, 90.5 × 72.5 cm
Amsterdam, Van Gogh
Museum

The painting should be considered as a companion to *Vincent's Chair* though a number of large differences are immediately apparent when the two are compared. The colors used are completely discordant: whereas Van Gogh had chosen for his own chair pale, luminous colors, for Gauguin's he used strong, dark tones. The strongest are the cold green and blue though these are mitigated by their pairing with the yellow of the books and the lamp and the brushwork that animates the floor. The brown of the chair is not particularly cheerful and helps to create the general dark tone of the painting. In a letter to the art critic Albert Aurier, Van Gogh had described the painting. The colors corresponded to the real ones but Vincent had made symbolic use of them, even in these two unusual "portraits."

Furthermore, while Vincent's chair is a simple straw seat, Gauguin's is more of an armchair, with a wider seat and arms. To symbolize the chair's occupant, Van Gogh added books and a candle. An oil lamp illuminates the room. Slightly younger than Gauguin, Van Gogh felt inferior to him ("I recognize that my artistic theories are too banal compared to yours," he had written). Despite being far from established as a painter himself, Gauguin had solid ideas and had proclaimed himself the leader of the "Pont-Aven school." Vincent, however, remained grateful to Gauguin, from whom he believed he had learned a great deal.

But Van Gogh was not a naïve soul. Before Gauguin's arrival he had confided to his brother, "instinctively I feel that he is a calculator" (letter to Theo 538, mid-September, 1888), and later, "On various occasions I have seen him do things which you and I would not let ourselves do, because we have consciences that feel differently about things. […] I think that he is carried away by his imagination, perhaps by pride, but…practically irresponsible" (letter to Theo 571, January 17, 1889).

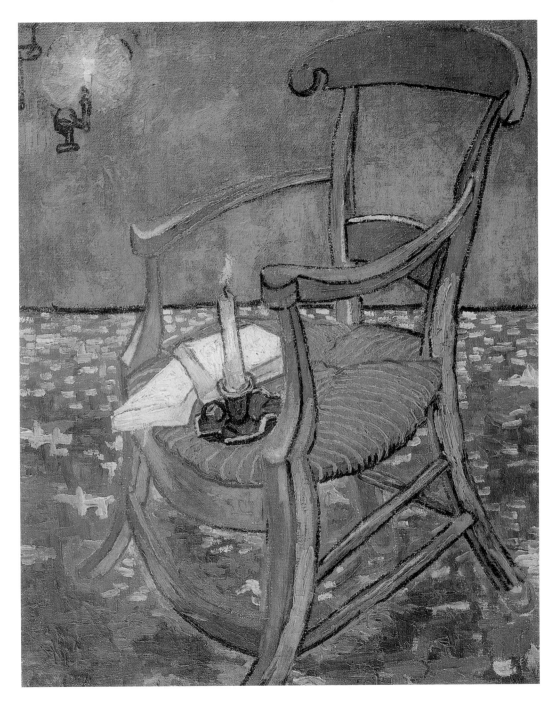

L'Arlésienne: Madame Joseph-Michel Ginoux (Marie Julien, 1848–1911)

1888
Oil on canvas, 91.4 × 73.7 cm
New York, The Metropolitan
Museum of Art

This is the first of many variants that Van Gogh painted of this portrait. It is of Madame Ginoux, the owner of the café in Arles where the artist used to spend his evenings and which was also the subject of several paintings. *L'Arlésienne* was painted when Paul Gauguin was living with Van Gogh, during a period that represented Vincent's dream of having a "studio in the south" where several artists could work together. He hoped that they might work on the same motifs and subjects, then compare their individual approaches in order to develop a new, joint art. Gauguin was therefore inspired to create his own vision of the café at night, something that Vincent had already done, but he completely altered the structure of the scene and placed the portrait of the owner in the foreground. Madame Ginoux had visited the Yellow House several times for the portrait sessions and while Gauguin made sketches that he would use for his painting, Van Gogh painted his own canvas.

Vincent's *L'Arlésienne* is a much stronger picture than his colleague's. He chose one of his dazzling color contrasts characteristic of his period in Arles, pairing the dark mass of the woman against the bright yellow background. Despite this monochrome flatness, the painting has a certain depth created by the semicircle of the green table and the three-quarter pose of the sitter. Van Gogh chose an innovative and unusual angle, as though it were a snapshot, which shows only a section of the table and even cuts off a corner of the open book.

The simplified forms give the portrait great power, and the observer's eye focuses on a few details: the blue ribbon in Madame Ginoux's hair which falls onto the chair-back; the light, colored expanse of the front of her white blouse; the elbow resting on the table; and the hand supporting her head, which gives her both a distracted and determined air.

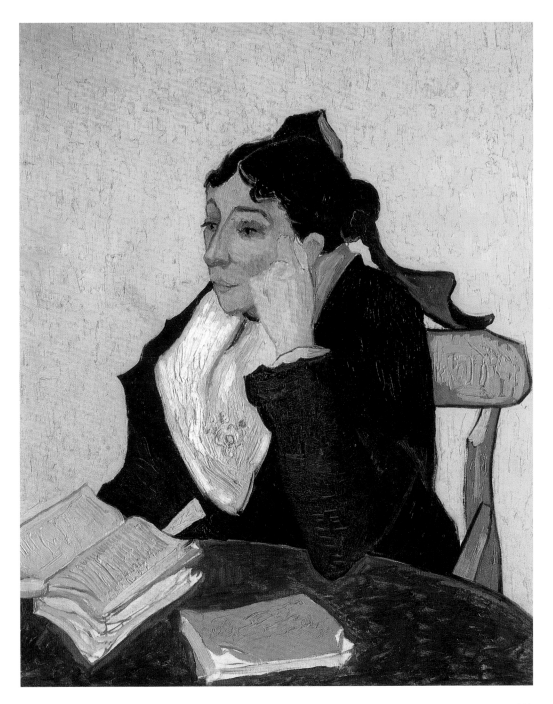

Spectactors in the Arena at Arles

1888
Oil on canvas, 73 × 92 cm
St. Petersburg, The State
Hermitage Museum

The center of Arles is dominated by a large Roman arena where still today bullfights are held in the summer. Van Gogh went to watch one and was impressed enough by the spectacle for the event to become one of his very rare crowd scenes. The central characters of the actual event—the toreador and the bulls—are only marginally included in the scene as the artist's attention is focused on the steps thronged with people viewed from above. He did not bother to describe the people individually and even those close to his viewpoint are only sketched in: what interested Van Gogh was to transmit the impression of the shouting crowd, which he makes more indistinct by the dominant green tone. The painting was executed in December while he was living with Gauguin and the influence of his friend is very apparent. Gauguin championed a technique called cloisonné or synthetism in which every detail was expunged and the artist concentrated on summarizing the main expanses, which he painted with flat blocks of color outlined with dark lines. In this painting Van Gogh, who was already moving along a parallel track, came close to Gauguin's technique, even renouncing his customary dazzling color combinations in favor of an almost ashen monochrome broken up by the black outlines of the figures.

It is very probable that the dialog between the two painters was even closer: one of Gauguin's most famous paintings was the *Vision of the Sermon* of 1888. It has a similar composition to Vincent's *Spectators* with a section of ground seen from above and a group of Breton women painted in his summary style. The two works bear direct comparison but, even if Gauguin painted his first, Vincent's animated crowd scene takes only the basic idea and builds upon it in a more personal style.

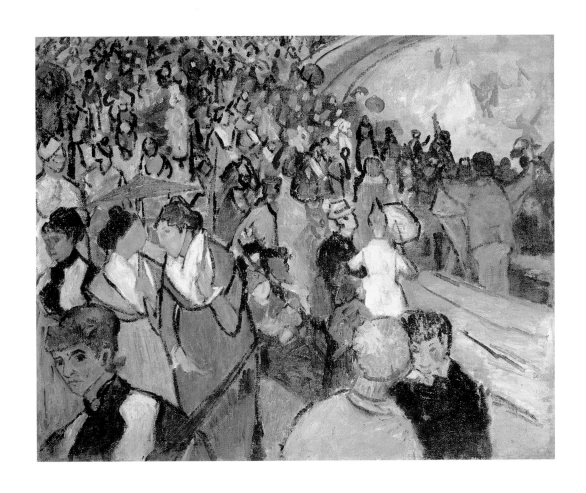

Breton Women

1888
Watercolor, 47.5 × 62 cm
Milan, Civica Galleria d'Arte
Moderna

This is one of the few paintings by the artist in Italy. The scene was inspired by a painting by Émile Bernard who worked for a long period in Brittany with Gauguin. Bernard was one of the creators of synthetism, the axioms of which are evident in the copy made by Van Gogh. The details are reduced to the essential, the surfaces flattened by uniform color and the use of black outlines. One of the axioms of synthetism was the refusal to work from the model but from memory and idea. Although Vincent had made several attempts using this approach, he did not agree with "abstractions" and soon went back to painting from reality. To his mind, this provided the only guarantee of an "authentic" picture that respected the essence of nature. Both independent and loyal at the same time, Van Gogh was not at all interested in once more becoming a member of one of the many contemporary pictorial movements and on several occasions stated that he wished to "immerse myself in reality, without any [...] Parisian prejudice," in other words, without the discussions centering on artistic labels that raged among art critics in the capital.

In the late 1880s Bernard's painting began to follow the route of religious mysticism and Vincent heavily criticized this new approach. "Le *Christ portant sa croix* is appalling. Are those touches of color in it meant to be harmonious? [...] I don't want to trouble my head with such things" (letter to Bernard 21, early December, 1889). Obviously Bernard did not like these criticisms and relations between the two painters seemed to cool, yet Bernard was one of the most ardent supporters of Van Gogh's painting and he did everything he could to bring it to attention. It was he who put pressure on the writer Albert Aurier to publish a first article on Van Gogh and it was also Bernard who helped Theo organize a retrospective after Vincent's death, an undertaking he maintained even after the death of Theo himself.

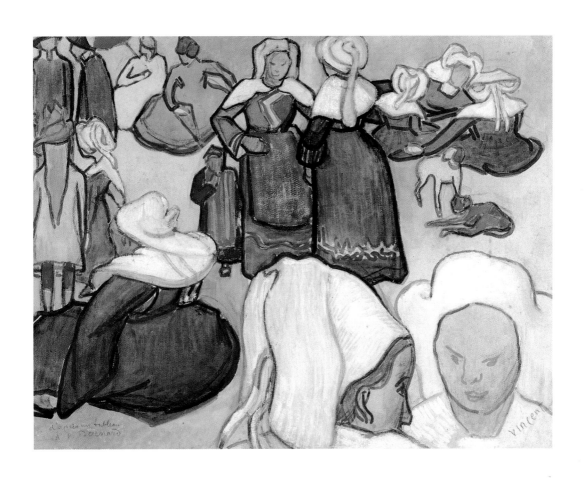

La Berceuse

1889
Oil on canvas, 92 × 73 cm
Otterlo, Kröller-Müller
Museum

The painting is of Augustine Roulin, the wife of Van Gogh's postman friend in Arles. The idea for the work came from a novel by Pierre Loti on the fishermen in Iceland and Vincent had thought of a picture that could be hung in the cabin of a boat to remind sailors of the cradle and lullabies. For this reason he called the work *La Berceuse*, and the result so pleased him that he made five versions of it, one of which was asked for by Gauguin. Vincent wanted this painting to be the central panel of a triptych, flanked by two paintings of sunflowers, in a sort of modern altarpiece in which art took on the role that was once held by religion.

Stylistically the work, painted in March 1889, was influenced by Gauguin. In accordance with the canons of cloisonnism, Vincent enclosed each block of color in a thick black outline with the exception of the woman's hands. When compared to the rest of the picture, this detail reveals the purpose of the outlines: the image is suggestive of a collage and—as we see clearly in the block of the woman's head—the individual sections appear to be flat profiles. The background of floral wallpaper, with its arabesque patterns, adds to the decorative potential of the surface which, when considered closely, is reminiscent of Japanese graphics. However, Van Gogh did not follow the style advice of his elder colleague to the letter: only some surfaces are flattened—the green blouse, the brown seat and red floor—whereas the rest of the work is executed with the artist's usual expressive brushwork, exemplified by the variations of pink and yellow in the face and the heavy impasto and thick brushstrokes in the green skirt.

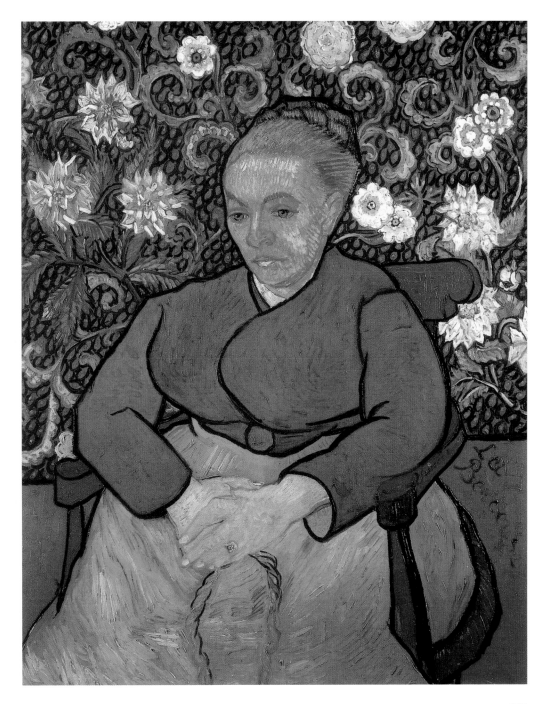

Portrait of Doctor Felix Rey

1889
Oil on canvas, 63 × 53 cm
Moscow, The Pushkin State
Museum of FIne Arts

At the end of December 1888 the brief experience of living and working together shared by Van Gogh and Gauguin ended in tragedy: at the height of a period of great tension, Vincent cut his right ear with a razor. Félix Rey was the doctor who cared for the artist and who became his friend at the same time. After explaining to Vincent that the abuse of tobacco and alcohol had certainly not done his health any good, Vincent replied that a degree of exaltation had been necessary for his artistic aims to have been realized.

This work shares some characteristics with *La Berceuse*, particularly in the use of a decorative background, but it does not have the symbolic qualities of the other painting. The doctor is shown half-length wearing a white collar and a partly unbuttoned blue jacket. In executing this painting Vincent did not comply with all of the artistic advice offered by Gauguin and synthetism: the black outline used to enclose every flat surface was not adopted systematically, for example, in the pocket and border of the jacket the black outline was replaced by a red line, and in the face it is decidedly thinner than in the portrait of Madame Roulin, even absent around the doctor's ear. Another aspect is that the free and variable brushwork is typical of Van Gogh's personal style: the blue of the jacket is applied irregularly and the brushstrokes in the man's hair and beard follow the direction of growth. The artist naturally concentrated his attention on the doctor's face; this is shown in full light with all the features carefully depicted: the pronounced nose, small but full mouth, high forehead, and dark eyes.

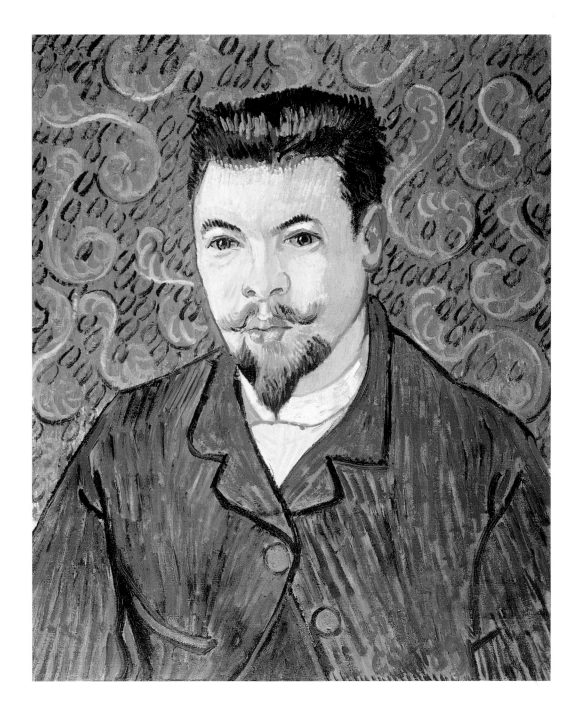

Self-Portrait with Bandaged Ear

1889
Oil on canvas, 60 × 49 cm
London, Courtauld Institute
Gallery

After the episode in which Van Gogh cut at his ear, rather than seeking treatment the artist shut himself in his room. Once he was back in action, after two weeks in hospital, he painted several self-portraits with his ear bandaged. The London version revolves around a harmony of cool colors. Vincent rendered himself in quarter profile with emphasis on his bandage. Portrayed at a moment of particular downheartedness, his gaze is not even in direct contact with the observer. The brushwork is broken into small vertical dashes and it is interesting to note (despite Vincent not embracing such theories) that during this period scientific treatises associated vertical lines with sadness in denoting states of mind.

The background is given by a green wall against which can be seen the vertical part of an easel with a partially prepared canvas, and one of Van Gogh's Japanese prints which he had begun to collect in Antwerp and that were a principal source of inspiration to his painting while he was living in Arles.

In this painting Vincent is almost unrecognizable. His face is thin and the brushwork is uneven, as though he was dwelling on following the outline of each bone. The unbuttoned jacket and cap helps to give the image a sense of closure that introduces an element of distance between the sitter and his surroundings. The artist spoke quite serenely about his condition and recognized the fact that he made people afraid. He was even able to joke about it: alluding to Gauguin's plans for a new trip to an exotic destination, he wrote to Theo that he was "too old and (especially if I have a papier-mâché ear put on) too jerry-built to go there" (letter to Theo 574, January 28, 1889).

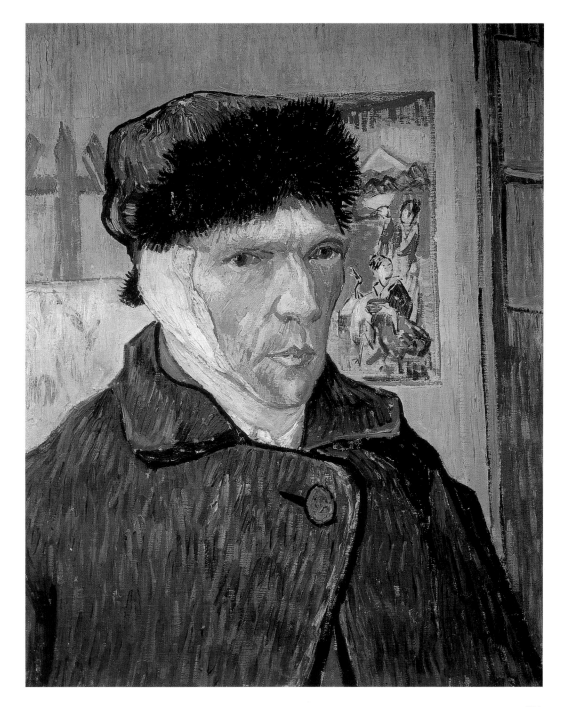

Pine Trees with Figure in the Garden at Saint-Paul Hospital

1889
Oil on canvas, 58 × 45 cm
Paris, Musée d'Orsay

The painting shows the front of the male ward of the asylum in Saint-Rémy. A man is coming out of the door while another, closer to the observer, even though his features cannot be made out, stands in the center of the composition. Van Gogh was allowed to leave the hospital to paint provided he was accompanied by a warder and he took advantage of this opportunity whenever his health permitted. The surroundings were very attractive—the asylum lay in the countryside a short distance from the village of Saint-Rémy de Provence—and the architecture of the building, which was itself ringed by trees, offered itself as a subject.

The painting skillfully juxtaposes several different forms. The horizontality of the building's facade, the sky and strip of ground is compensated by the sturdy mass of the tree in the foreground; its trunk twists out of the picture but a section of its foliage hangs down from above.

The solid block of the steps also helps to balance the composition and the space at the center, which would otherwise be empty, is occupied by the man standing relaxedly with his hands on his hips.

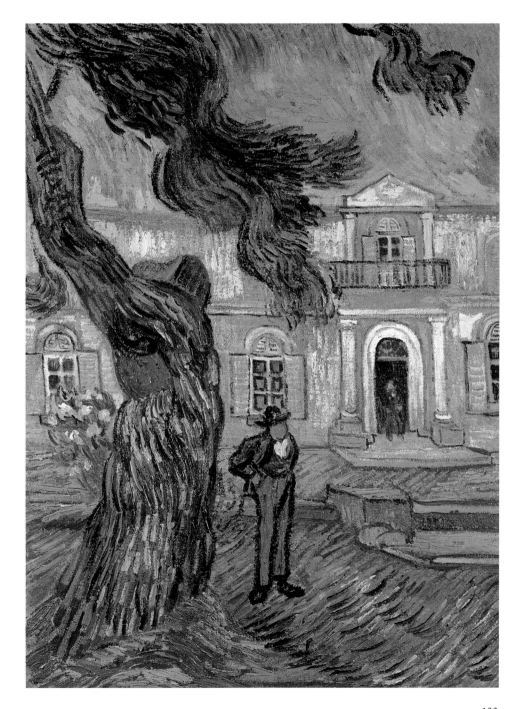

The Garden of Saint-Paul Hospital

1889
Oil on canvas, 64.5 × 49 cm
Private collection

S aint-Paul-de-Mausole asylum in Saint-Rémy was once a monastery built in the twelfth or thirteenth century and later renovated. The internal garden, where Van Gogh often painted during the year he voluntarily spent at the asylum, occupied the space where at one time the cloister had stood.

This painting was executed in autumn 1889, several months after the artist had entered the asylum, a decision he had taken with full awareness and serenity. In a long letter to his brother he explained that he had "tried to become accustomed to the idea of restarting, but for the moment it is not possible. I would be afraid of losing the power of working, which is now coming back to me. […] Temporarily I wish to remain shut up as much for my own peace of mind as for other people's" (letter to Theo 585, April 21, 1889). At first he was happy with the decision he had taken. He had no responsibilities beyond those he wished to take and he had begun to put into practice the program he described to Theo in the same letter: "I shall do a little painting and drawing without putting such frenzy into it as a year ago." However, around October he began to announce more frequently his decision to leave the asylum, which he had begun to find oppressive. The colors in his paintings reflected his state of mind, becoming ever paler. The work has many of the aspects of other canvas from this period, for example, the presence in the close foreground of two trees, which almost presses the observer against the picture, and the decorative lines typical of Japanese art seen in the twisted trunks of some of the trees. The sky has become ornamental with the use of a series of curved lines that only differs from the foliage of the trees by its color, with the result that the horizon seems to no longer to exist. The surface of the work appears to waver in front of our eyes, almost as though it were in movement.

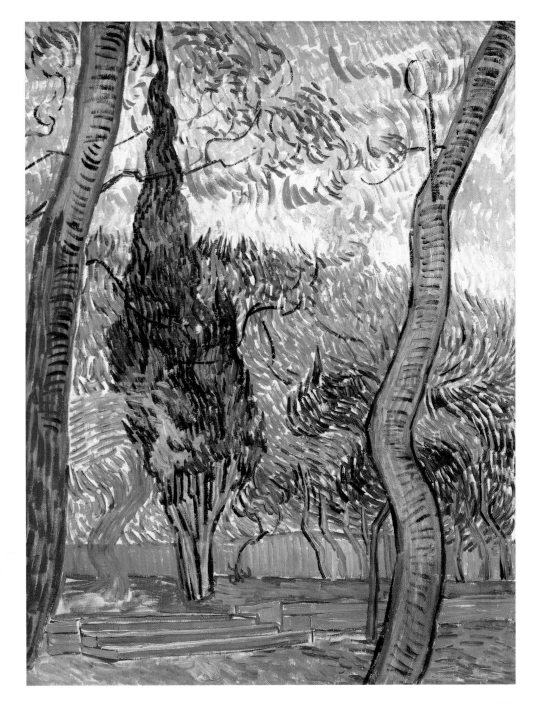

Lilacs

1889
Oil on canvas, 73 × 92 cm
St. Petersburg, The State
Hermitage Musem

Lilacs was painted shortly after Van Gogh's voluntary internment in Saint-Paul-de-Mausole asylum in Saint-Rémy, near to Arles. Despite the insistence of his brother Theo that he should not enter an asylum, Vincent was adamant. Sure that he was too fragile to live alone, he wanted to be somewhere that offered shelter and where he could recover. The start of his stay there was serene: though he did not receive any particular therapies, he had been given two rooms, one to sleep in and the other to use as a studio. More important, he had been given permission to paint outdoors if he was accompanied by one of the nurses.

This painting, with its joyful and energetic colors, reflects this atmosphere of relative peace. The large lilac tree occupies the center of the painting, which was probably executed in the hospital garden. On the far right there is a low brick wall, and a gray path runs past the large green mass of the bush. Beside the path there is a yellow shrub and a patch of irises that Van Gogh was later to feature in several extraordinary paintings.

The work also reveals the degree to which the garden was unkept: the vegetation seems wild, which matches the contemporary descriptions we have. The brushwork is composed of small strokes and patches of color that were impressionist in inspiration, but the two-dimensionality of the purely ornamental tree trunk on the right of the canvas is a return to the influence of the artist's Japanese prints. Only the violet sky offers a presentiment of the latent anxiety of the artist, who was still severely shaken by the first hallucinatory attacks he had suffered.

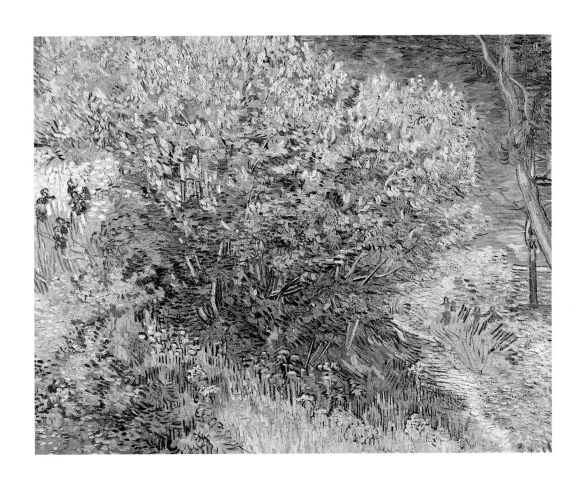

Irises

1889
Oil on canvas, 71 × 93 cm
Los Angeles, The J. Paul Getty
Museum

Van Gogh painted several of his most beautiful canvases of the irises in the garden in Saint-Rémy. Here he has shown the flowers up close, viewing them almost from ground level and eliminating the horizon altogether. The resulting view is highly concentrated and the observer feels almost immersed in the scene. At first glance the painting may seem chaotic but the artist in fact carefully organized the masses and colors. The close view of the irises in the right foreground is balanced by the expanse of soil beside them, the reddish color of which finds an echo in the flowers at the top of the picture. The small strip of grass seen at top right offers a second instance of "emptiness" and balance.

The canvas is crossed diagonally by the irises and is dominated by the elegant matching of the bright green of the spear-shaped leaves and the intense violet of the flowers. The plants have been given a highly ornamental quality and, as the artist had done on various other occasions, he filled the entire field of view, allowing the flowers to continue out of the picture frame. This expedient, typical of Japanese art, increases the decorative character of the work and, with the inclusion of a black outline around the petals and stems, almost gives the impression that Van Gogh was painting a pattern from wallpaper on top of a natural setting.

Irises was one of the few paintings exhibited during Van Gogh's lifetime: it was sent by his brother Theo to the Salon des Indépendants in September 1889.

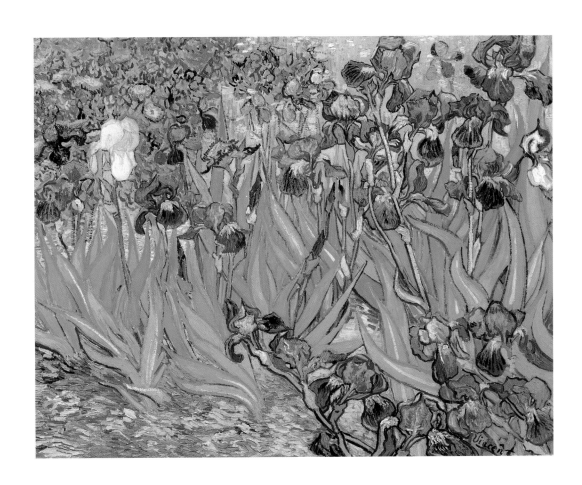

Irises

1890
Oil on canvas, 92 × 73.5 cm
New York, The Metropolitan
Museum of Art

"At present all goes well […] I am doing a canvas of roses with a light green back-ground and two canvases representing big bunches of violet irises, one lot against a pink background in which the effect is soft and harmonious because of the combination of greens, pinks, violets. On the other hand, the other violet bunch (ranging from carmine to pure Prussian blue) stands out against a startling citron background, with other yellow tones in the vase and the stand on which it rests, so it is an effect of tremendously disparate complementaries, which strengthen each other by their juxtaposition" (letter to Theo 633, May, 1890).

This is how Vincent described the work before he started it. The passage is doubly significant: on one hand because he describes the intentions that underlay the painting, on the other because it sheds light on the way Van Gogh worked. Although he called himself "a passionate painter" and said he produced his paintings straight off, behind them there lay a phase of mental preparation. When he approached the canvas, he already had a clear idea of what he wanted to achieve.

When Van Gogh first went to Paris, he painted still lifes of flowers based on the works of the romantic painter Monticelli. Later, in Arles, he painted the series of *Sunflowers* with which he completely revolutionized the genre. In *Irises* the artist manages to capture the exuberance of nature: the shoots are hardly contained in the vase and seem to have a life of their own, the flowers push against one another and the bunch seems to spread in all directions. Chromatically, Vincent fully achieved the effect he was looking for. The colors "sing" and their violent harmony, barely softened by the three groups of long green leaves, becomes a symphony.

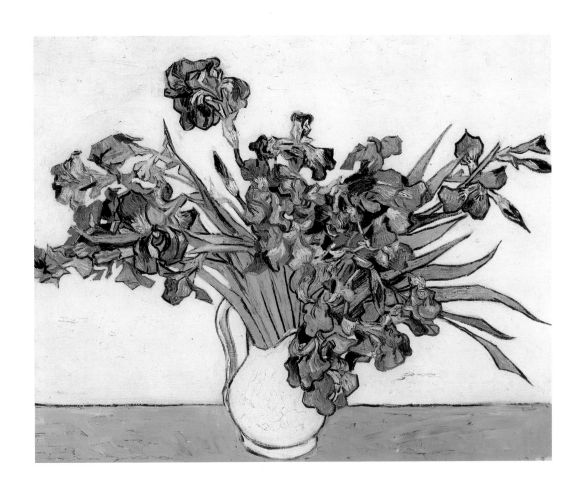

Still Life with Drawing Board, Pipe, Onions and Sealing Wax

1889
Oil on canvas, 50 × 64 cm
Otterlo, Kröller-Müller
Museum

Van Gogh had often painted still lifes, that is to say, compositions of inanimate objects. This one, however, is unusually crowded. On and around a table, a bunch of very diverse objects are piled: an empty bottle, some onions, a plate, a burning candle, a postcard, a teapot, a book, a pipe, and tobacco and sealing wax. The different shapes, materials, and consistencies of the objects lay at the center of Van Gogh's interest. He dwelt on the roughness of the wooden table, the cover of the book that is falling apart, the transparency of the glass and the green leaves of the onions. The painting as a whole amply demonstrates the two tools the artist used to express himself: color and brushwork.

As was typical of his Arles period, the colors are bright with the principal note given by the brilliant yellow of the table. The cooler greens and blues are equally bright and even the darker areas—like the inside of the teapot and the lower edge of the table—do not stifle the overall agreement, on the contrary, they balance it. Though he did not make use of the curved or spiral brushstrokes that he was later to employ, Van Gogh combined strokes of different direction and length as was required. The table is formed by colorful horizontal strokes that contrast with the vertical ones of the bottle and the broken strokes that suggest the forms of the onions. The far wall, on the other hand, is enlivened with short strokes of different colors that call to mind the artist's interest in impressionist and pointillist techniques.

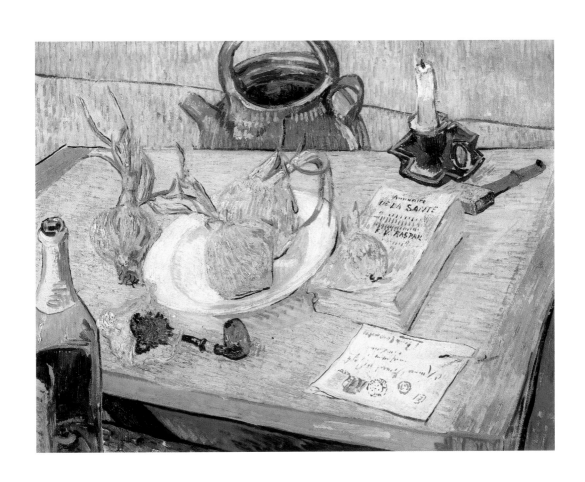

The Starry Night

1889
Oil on canvas, 73.7 × 92.1 cm
New York, The Museum
of Modern Art, Lillie
P. Bliss Bequest.
Digital Image © 2002
The Museum of Modern Art,
New York

In the second half of the 1880s Paul Gauguin and Émile Bernard developed symbolic painting based on the products of their imagination rather than the real world. In the many discussions on the subject between Van Gogh and his two friends, Vincent declared he did not want to create "abstractions" but that he wished to have direct contact with the reality of nature. However, he admitted he found himself in great difficulty in his desire to paint the sky at night. Unwilling to paint in his studio what he could not see in front of him, the artist dreamed up a bizarre though ingenious system: he fixed candles to the top of his hat and thus painted the first nocturnal view *en plein air* in history.

Although he worked with a "live" subject, the result is anything but realistic. Vincent's powerful imagination transformed the scene into a sort of cosmic event: the sky seems raked by a shower of whirling comets and the imaginary village appears immersed in a supernatural atmosphere.

This strong and vibrant painting is carefully constructed and its apparent impetuousness is surprisingly underpinned by a solid composition. The diagonal line of the mountains emphasized by a series of yellow waves—as though the Milky Way had collapsed onto the horizon—crosses the canvas from one side to the other. The rounded and spiral brushstrokes that make up the stars are also seen in the trees between the houses, while the tall spire of the church is mirrored in the dark, energy-filled and solitary cypress in the foreground. Vincent was highly intrigued by these trees and was astonished "that they have not yet been done as I see them. It is as beautiful of line and proportion as an Egyptian obelisk" (letter to Theo 434, June 25, 1889).

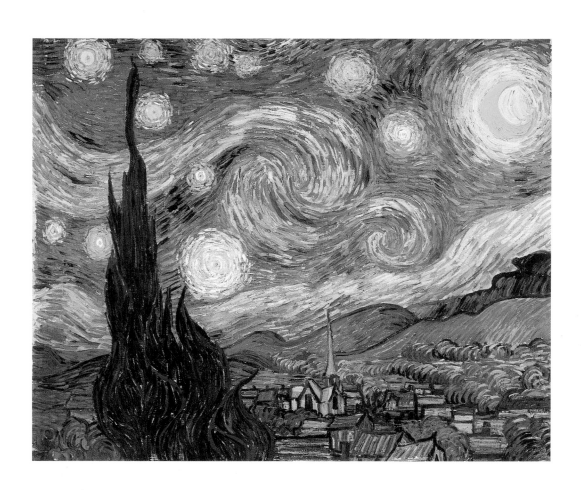

Self-Portrait

1889
Oil on canvas, 65 × 54 cm
Paris, Musée d'Orsay

Van Gogh painted a large number of self-portraits during his brief artistic career, leaving a series of images of extraordinary psychological penetration. His repeated use of himself as a model also had a practical motive: the lack of people willing to sit for him. This circumstance, about which he often complained, afflicted him as he considered portraiture to be the principal genre of his painting. While he was in the hospital at Saint-Rémy, during the months that followed one of the worst attacks of delirium he suffered, Van Gogh painted exclusively inside the asylum and produced six self-portraits. This one, in the Musée d'Orsay, is one of the most intense. He portrays himself in three-quarter profile dressed unusually in elegant fashion. His hair is brushed back leaving his forehead bare. His expression is tense, almost aggressive, and his gaze makes the observer feel slightly uneasy. His eyebrows are contracted and his mouth is curved slightly downwards. The portrait shows a serious, intense man, the psychological dimension of whom is accentuated by the execution of the painting. The work is dominated by blue, which is even reflected on the skin of his face, his lips, and hair, thereby flooding the figure in an unreal light. The symbolic function of color and the extent of the artist's "sensitive" brushwork in this painting are some of the most intense achieved by Van Gogh. Wavy strokes are used to suggest the forms of the jacket and are combined with spirals and whirls of color in the completely abstract backdrop to create a powerful psychical impact. These create a feeling of continuous interior torment and permanent anguish, and make this painting one of the artist's most dramatic works.

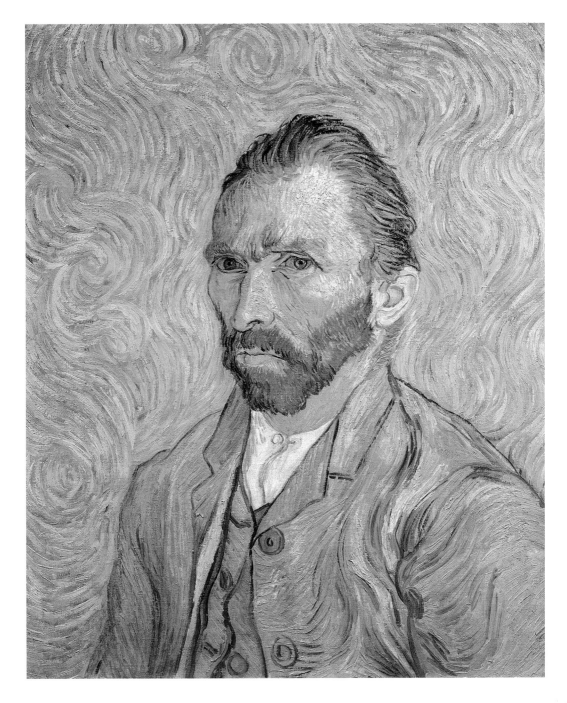

Hospital Ward in Arles

1889
Oil on canvas, 74 × 92 cm
Private collection

This painting depicts the interior of Saint-Paul-de-Mausole asylum, the rather depressing nature of which was contrasted by the external architecture, cloistered garden, and surrounding countryside. In some photographs we see long, low, dismal corridors with barred windows. However, Van Gogh did not sleep in the dormitory but had two rooms that looked over the fields, one of which he used as a painting studio. The care offered to the inmates was fairly superficial, partly due to the avarice of the director of the asylum. Even though he considered Van Gogh to be affected by acute mania and attacks of epilepsy, the only treatment Vincent was prescribed was two long baths weekly. The painter commented that "The treatment of patients in this hospital is certainly easy [...] for they do absolutely *nothing*" (letter to Theo 605, September 10, 1889). He was convinced that the best remedy for himself was painting, the only activity about which he was passionate to the point that it absorbed him entirely.

The painting gives the sensation of the abandonment to which the patients were left, shown here huddled around a stove. Nonetheless, the atmosphere is not sad: almost each of the patients is intent on his own activity, the enormous room is reasonably well lit and the green of the walls, ceiling, and curtains around the beds gives the setting a certain serenity. The forms are given a sure but synthetic treatment and outlined in black but the colors used and physical poses of the sick almost suggests the early Dutch paintings of which Vincent had made copies.

The presence of other patients was a comfort to Van Gogh: "I think I have done well to come here, because, by seeing the *reality* of the assorted madmen [...]. I am losing my vague dread, my fear of the thing. And bit by bit I am getting to consider that madness is just a disease like any other" (letter to Theo 591, May 10–15, 1889).

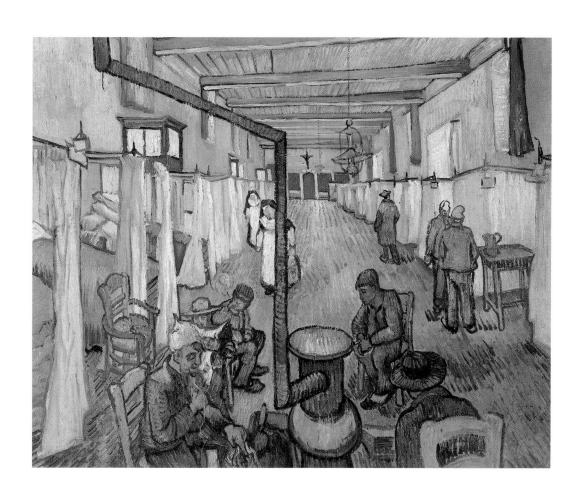

Prisoner's Round
(after Gustave Doré)

1890
Oil on canvas, 80 × 64 cm
Moscow, The Pushkin State
Museum of Fine Arts

Vincent painted *Prisoner's Round* while he was staying in the asylum at Saint-Rémy. He produced many copies of well-known paintings, partly because he was not allowed to go out to paint following some of the attacks he suffered, and partly because he chose to stay in his studio-bedroom. One of the copies he made was from Gustave Doré's *Newgate. The Exercise Yard* which was published in 1872 in the book *London, a Pilgrimage.*

Without question, the subject of the painting reflected Van Gogh's spirits. At the start of 1890 he wrote to Theo that he wanted to leave the asylum and return to northern France as he found the atmosphere in the south increasingly oppressive.

The scene is lit by an unreal blue light and is infused with a sense of claustrophobia. Not only is there no horizon and the walls of the prison seem to stretch away to infinity, but the polygonal form and endlessly circling ring of prisoners heightens the feeling of enclosure. The prisoner closest to the edge of the canvas and who looks at the observer is a self-portrait of Van Gogh, who was at this time counting on "escaping" in the near future.

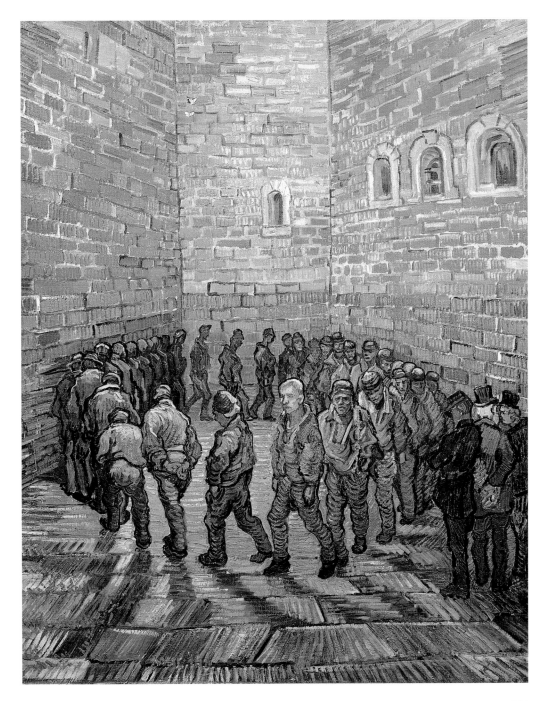

151

L'Arlésienne (Madame Ginoux)

1890
Oil on canvas, 60 × 50 cm
Rome, Galleria Nazionale
d'Arte Moderna

Several versions were made of this painting, all in February 1890 in the Saint-Rémy asylum. While living in the Yellow House, Gauguin made several drawings of Madame Ginoux, the owner of the café in Place Lamartine in Arles. Based on these and his visits to the café he made a painting of the interior of the bar by night, with the figure of the woman seated at a table in the foreground (now in the Pushkin Museum in Moscow). Vincent had made several oil portraits of Madame Ginoux but in this example he took his cue from his friend's drawings. On the whole his copies were pretty faithful to the originals, but he took a few liberties with the design and, above all, with the colors. These bore no relationship to the original (this was made easier for him by the fact that the reproductions he had were often in black and white) and allowed him to consider them as recreations rather than copies, or, better, to use his own words, translations into another language. In the case of *L'Arlésienne*, Van Gogh followed this procedure: he closely followed the design but arbitrarily chose colors though without distorting the general tone. He wrote to Gauguin, "I tried to be religiously faithful to your drawing, while nevertheless taking the liberty of interpreting through the medium of color the sober character and the style of the drawing in question. [...] Take this as a work belonging to you and me as a summary of our months of work together (letter to Gauguin, June 17, 1890).

When viewed beside his own earlier version, this painting based on Gauguin's design seems to be of a different woman: in Van Gogh's painting in the Metropolitan Museum in New York, Madame Ginoux appears resolute and the bright colors increased the impression of strength. In this version in Rome she seems tired and aged; her mouth has a bitter twist and her gaze is veiled by sadness.

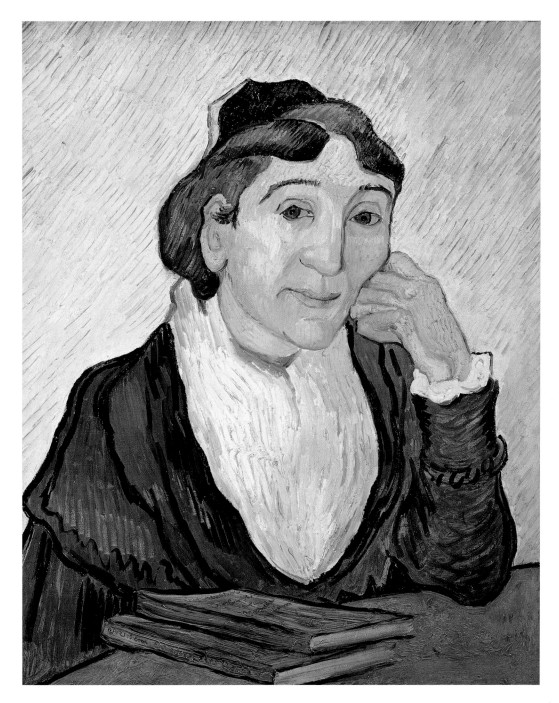

Sprig of Flowering Almond Blossom in a Glass

1888
Oil on canvas, 24 × 19 cm
Amsterdam, Van Gogh
Museum

Van Gogh had gone to Arles expecting to find warm light and Mediterranean colors but on his arrival he found the countryside covered in snow. However, the event was exceptional for a southern region and the artist was soon repaid with an explosion of color in spring. He was particularly struck by the fruit trees in blossom, whose slender, elegant structure crowned by white petals reminded him of the graceful lines seen in Japanese prints. Vincent produced a large number of drawings on this subject, trying to profit as much as possible during the short period of fruit blossom. This small painting has turned the simple motif of the trees in flower into a still life. It is both simple and refined: it is very far from the stately, colorful vases of flowers he painted in Paris along the lines of Monticelli. Here he reduced to the minimum his means, hinging the work of the play of filled and empty spaces. In a glass positioned deliberately off-center, he placed a sprig of almond blossom and then filled the pictorial space by emphasizing the diagonal axis of the twig. The table (or floor) and wall behind are painted in a summary manner, the former dashed in using rapid, bright brushstrokes with the blue shadow of the glass surrounded by yellow and green stripes. The more finished surface of the wall is flatter and has a variation in tone that separates it into two asymmetrical sections; the boundary between the two is marked by a clearly visible red line, the same color that Van Gogh used to sign his name at top left. The focus of the scene is the twig, whose groups of white buds, painted with great freshness, fill the painting with life. With radical simplification, Vincent has produced a highly balanced painting, the simplicity of which is transformed into a tangible delicacy.

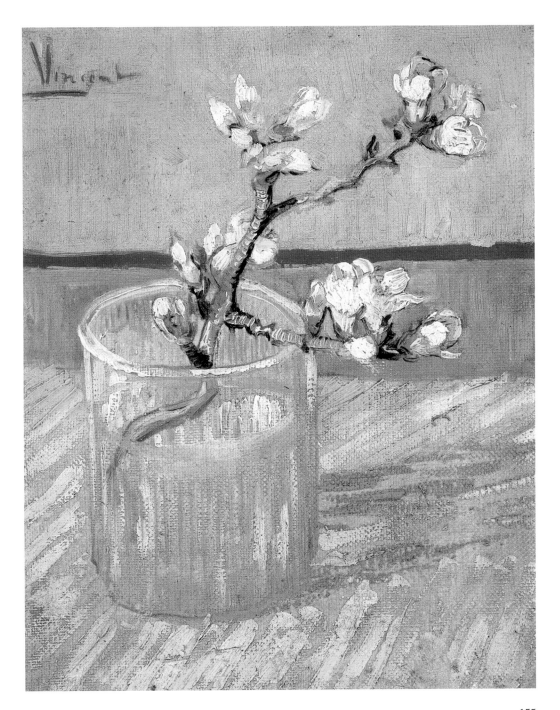

155

Thatched Cottages in Cordeville

1890
Oil on canvas, 72 × 91 cm
Paris, Musée d'Orsay

This was the first painting Vincent made in Auvers-sur-Oise where he moved at the suggestion of his friend, the painter Camille Pissarro, when he left the asylum in Saint-Rémy. The houses in the village, which could be reached in a few hours from Paris, were mostly thatched cottages along the narrow country lanes. Vincent's first impression was that Auvers "is profoundly beautiful, it is the real country, characteristic and picturesque" (letter to Theo 638, May 20, 1890).

The painting reflects the artist's description. The yellow that dominated his paintings in Provence has almost disappeared and Van Gogh made use of a cold, pale set of greens, blues, and violets. The brushstrokes are curved and twisted, the dark trees in the background and even the irregular roofs seem alive, and there are no figures. The sky seems to suggest a windy day yet overall the scene appears still and dominated by a sense of expectation. Here the artist has given form to an intense, practically tumultuous vision, in which every object seems to be undergoing a process of transformation and the broken lines of color have a life that is independent of what they are supposed to represent.

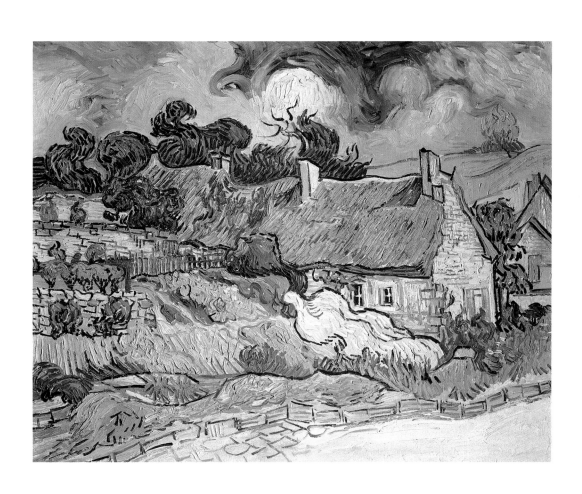

Portrait of Dr. Gachet

1890
Oil on canvas, 68 × 57 cm
Private collection

Paul Gachet was a doctor, art lover, and amateur etcher. He had met Victor Hugo, frequented Paris cafés where the impressionists gathered and was the friend of several painters, including Paul Cézanne and Camille Pissarro. It was in fact Pissarro who suggested the village of Auvers-sur-Oise to the Van Gogh brothers as a place where Vincent might stay. It was an excellent solution. Gachet was a very unusual person and immediately created a bond with Vincent who, after a year of isolation in Saint-Rémy, finally met someone with whom he could share his views on art. He also found in the doctor a willing model and, just two weeks after his arrival, began to portray him in a flurry of intense activity. Gachet liked the painting and even asked Vincent to make a replica of it.

Vincent described the portrait to his brother thus: "the head with a white cap, very fair, very light, the hands also a light flesh tint, a blue frock coat and a cobalt blue background" (letter to Theo 638, June 3, 1890). The painting was extremely innovative: Van Gogh abandoned the static, conventional poses he had used in his portraits in Arles and portrayed his friend in a casual posture. In Gachet's sad expression Vincent saw "the disenchanted expression of our time" (letter to Theo 643, mid-June, 1890). There is a strong contrast in the colors. The space is divided diagonally by the edge of a red table on which Dr. Gachet is resting. The painting is composed of several types of brushstroke: the table is created fairly flatly whereas the jacket and a part of the background are formed by curved lines; the upper part of the work, which is split in two by a wavy line and forms a sort of ornamental motif behind the doctor's head, is filled with the energy-filled dashes that he had used in the *Garden of Saint-Paul Hospital* and *The Starry Night*.

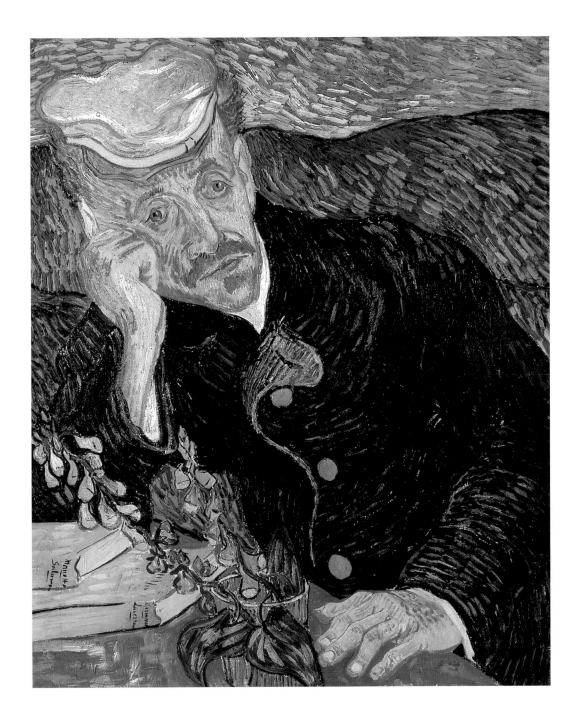

Marguerite Gachet in the Garden

1890
Oil on canvas, 46 × 55 cm
Paris, Musée d'Orsay

Dr. Gachet lived in one of the few brick houses in the village of Auvers and had a large garden. Van Gogh painted the garden in bloom in June and set the figure of Marguerite, the doctor's young daughter, in its midst. The painting seems impressionistic in its simple layout and the immediacy of the scene. Monet, Renoir, and Pissarro had often produced similar images and one can hypothesize that Vincent wanted to make a sort of homage to their art—which was particularly loved by Paul Gachet—in this painting.

Nonetheless the painting is still imbued with Vincent's personal and extremely concise style. The individual plants are not distinguishable and Van Gogh transforms the image of the garden into a triumph of greens and whites. The vegetation seems to swell like a cloud and even some of the light, airy cypresses appear to have no consistency. There are few elements to suggest that the scene is set in a garden rather than a field. The doctor's house is seen in the background with another roof, and several colored vases stand in a line by a fence. A low gate can just be made out among the plants behind Marguerite.

In this painting Van Gogh turned his back on the large, colorful monochrome expanses he had made use of in Arles in favor of a general mix of tones. The exception to this approach is the figure of Marguerite herself, whose white dress and yellow hat form a luminous and light patch at the center of the painting.

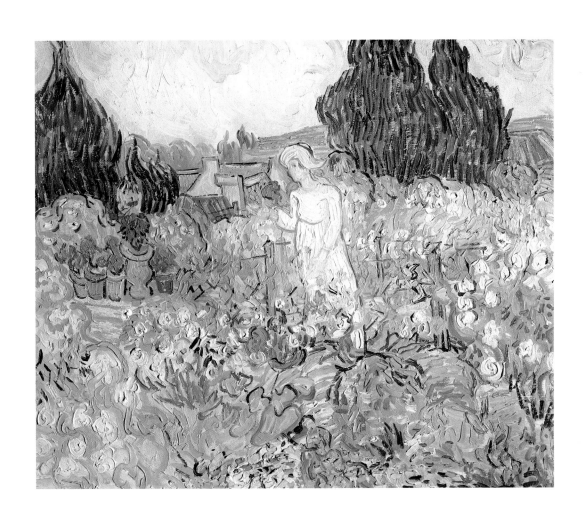

Marguerite Gachet at the Piano

1890
Oil on canvas, 102.6 × 50 cm
Basel, Kunstmuseum

Dr. Gachet's nineteen-year-old daughter, whom Van Gogh had painted in the garden, posed for him at the piano. Though this is not a real portrait, the artist was undoubtedly pleased to be able to paint the human figure. The girl is seen in profile with her hair tied up and eyes looking sadly, rather than intently, down at the instrument. Her skin is very pale, almost diaphanous, and, with her long white dress, creates a tone-on-tone effect. The energetic painting revolves around three colors: the luminous mass that represents the figure is reflected in the piano keys and music score, the green wall behind dotted with red spots, and the dark, reddish-brown floor and piano. Whereas the colors are deliberately restricted, the execution is intense and elaborate with a thick, doughy impasto saturated with color, particularly in the white dress, the heaviness of which is clear even in the photograph. As in the portrait of the girl's father, Vincent portrayed Marguerite using different techniques. The heavy strokes seen in the dress follow the direction of the material but are also seen on the red floor overlaid with brown. Using the same technique employed in Arles, the background wall is formed by a monochromatic cross-hatching whereas the wood of the piano is depicted with long brown streaks.

During a short visit to Theo, Vincent made a trip to the studio of Toulouse-Lautrec to see his friend's latest works. The painter had recently completed *Madamemoiselle Dihau Playing the Piano*, of which the resemblance to this painting is striking. Vincent was astounded and told his brother that he had seen the similarity with emotion.

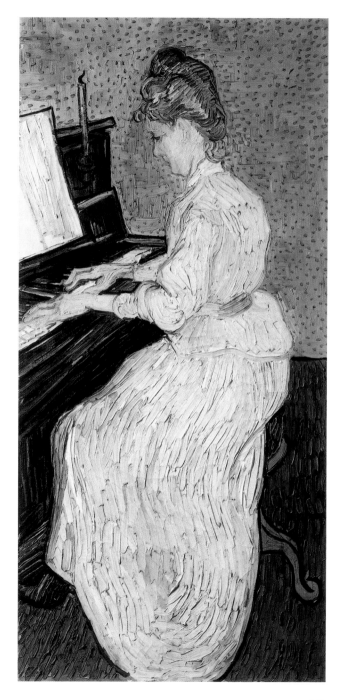

163

The Church in Auvers

1890
Oil on canvas, 94 × 74 cm
Paris, Musée d'Orsay

In 1884, while he was still living with his parents in Nuenen at the start of his artistic career, Vincent had painted the village church. The small building seen from the side of the apse, with its slender central bell tower, was shown against a background of sky and trees as a group of people came out after attending Sunday mass.

Less than a month before his death, the *Church in The Auvers* seems to have a relationship with the early work, the latter being a transformation of the former and summarizing the painter's dramatic artistic development.

The church in Auvers, also rather small, is similarly placed in the pictorial space. Here too, Van Gogh has painted it from the side of the apse and placed the walls in shade. Only two trees are visible in the distance and the low but solid bulk of the building rises forcefully at the center of the picture against a deep blue sky. In this case the small group of people is absent and only a single woman, seen from behind, walks along the edge of one of the two paths that pass on either side of the church.

The painting has an extraordinary power but is also a symbol of total isolation. We see the church from a slightly raised point of view, its windows are completely dark and its shadow reaches toward us across the grass. The only human being is seen from behind, thus preventing the observer from participation in the scene, and the two paths that separate in the foreground pass by the church on both sides without giving access to it. It is, however, the dark, almost stormy sky, painted with whirling brushwork, that governs the somber, oppressive and silent atmosphere of the painting. Van Gogh had by this time lost all means of access to the divine and his faith in painting, which had replaced his religious faith, was also fading.

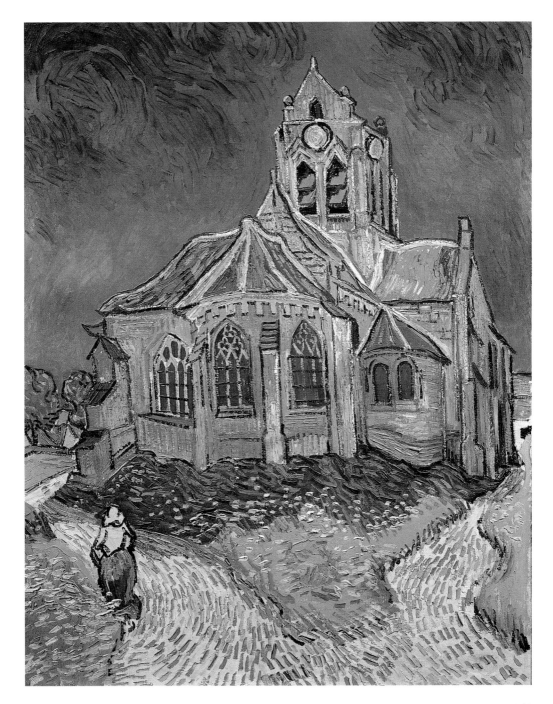

165

Wheat Field with Crows

1890
Oil on canvas, 50.5 × 103 cm
Amsterdam, Van Gogh
Museum

In February 1890 Van Gogh had written from Saint-Rémy to excuse himself "that my paintings are almost a cry of anguish" (letter to Wil 20, February 20, 1890). His move to Auvers had at first cheered him, thanks to his friendship with Dr. Gachet. Furthermore his paintings exhibited at the Salon des Indépendants and Les XX in Brussels were beginning to meet with critical approval and Theo had had a son which he named Vincent.

At the start of July, though, things once again came to a head. Theo had serious professional problems and his wife and son both fell gravely ill. Vincent went to Paris to see Theo but his brother's worries destroyed his own laboriously rewon confidence. He had always felt guilty about his financial dependence on Theo and his dejection once again raised his fear of fresh mental attacks. He even reached the point of breaking off with Dr. Gachet so that he remained completely isolated. On the evening of July 27 he went out into the fields and shot himself with a pistol, dying two days later in the presence of his brother.

With *Church at Auvers*, the *Wheat Field with Crows* can be considered Van Gogh's artistic and spiritual testament. Painted a few days before his suicide, it reflects the existential drama of the artist. Even though the pairing of blue with yellow is seen again, on this occasion it has lost all of its joyousness. The painting is dominated by a dark, menacing atmosphere and the flight of the crows does not in any way ease the tension. The overcharged colors were applied with a broken, angular brushwork.

Only five years had passed since he had painted *The Potato Eaters*, his first important work. The artistic parabola of Van Gogh had been very short and his development lightning fast.

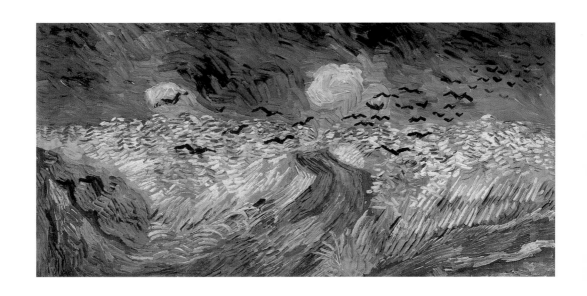

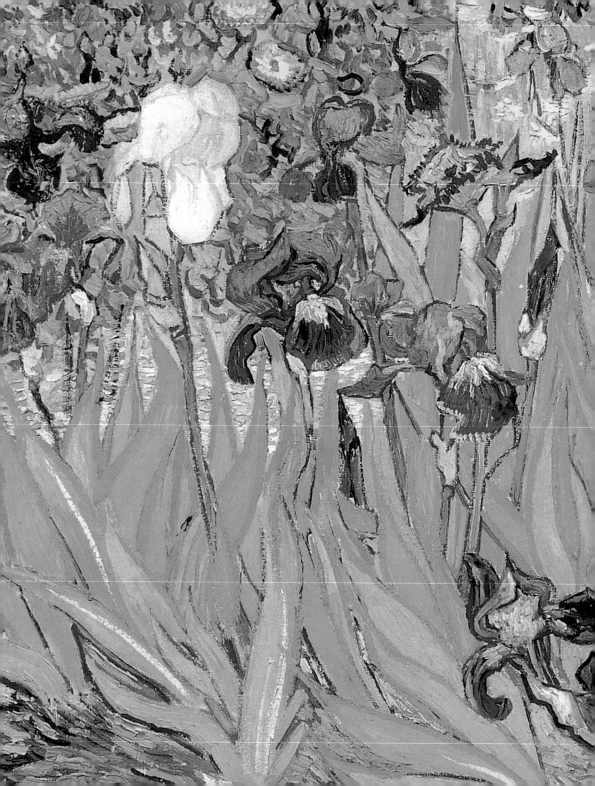

Appendix

Chronological Table

	Life of Vincent van Gogh	Historical and Artistic Events
1853	Vincent Willem van Gogh is born at Groot Zundert in north Brabant in Holland on March 30. He is the eldest child of Theodorus, a Protestant minister, and Anna Carbentus.	
1855		Important artists exhibited at the Exposition Universelle in Paris are Delacroix and Ingres. Courbet exhibits in the Pavillon du Réalisme.
1857	His brother Theodorus, called Theo, is born on May 1.	Flaubert is branded immoral following publication of his novel *Madame Bovary*. Baudelaire publishes *Les fleurs du mal* and is fined for offending public morality.
1862		Hugo publishes *Les misérables* and Dostoevsky *The House of the Dead*. Cézanne leaves his job in a bank and takes up painting. Monet works with Jongkind and Boudin in Le Havre.
1866	Vincent studies at the technical institute in Tilburg until March 1868.	Zola writes *Mon salon*, dedicated to Cézanne. The Goncourt brothers publish *Manette Salomon* and Dostoevsky *Crime and Punishment*. Corot and Daubigny become members of the panel for the Salon.
1868	He halts his studies and returns to Groot Zundert.	Redon reviews the exhibition at the Salon and praises Courbet, Daubigny, and Pissarro, while Zola commends Manet and Pissarro. Cézanne is rejected by the Salon.
1869	He leaves for The Hague where he is employed in the branch of the Paris art dealer Goupil & Cie.	Opening of the Suez Canal. Manet exhibits *Le Déjeuner sur l'Herbe* at the Salon. Like Monet and Sisley, Cézanne is once more rejected by the Salon.

	Life of Vincent van Gogh	Historical and Artistic Events
1870		The Franco-Prussian war breaks out on July 18 and the Third Republic is proclaimed on September 4. Manet is an officer in the National Guard under Meissonier. Pissarro flees to Brittany and then England. Cézanne avoids the draft and Monet leaves for England. Renoir, who was called up, is sent to Bordeaux and then Tarbes in the Pyrennes. Bazille enrolls in a regiment of zouaves and is killed at Beaune-la-Rolande on November 28. Paul Gauguin serves on the cruiser "Jérome Napoléon."
1872	In August he spends a few days with Theo at The Hague. It is following this visit that the correspondence between the two brothers begins.	With Jongkind, Pissarro, Cézanne, Renoir, and others, Manet signs up to a new Salon des refusés. Pissarro settles in Pontoise.
1873	Theo enters the Brussels' branch of Goupil & Cie and Vincent goes to work at Goupil's in London.	Napoleon III dies. Courbet flees to Switzerland, Cézanne settles in Auvers-sur-Oise and works in the house of Dr. Gachet.
1874		First impressionist exhibition in the studio of the photographer Nadar. Manet refuses to participate, Monet exhibits his painting *Impression, sunrise* from which the name of the group is coined.
1875	In May Vincent is back at Goupil in Paris. He reads and comments on the Bible. He visits museums and is enthusiastic about Corot and the Dutch seventeenth-century painters. He spends Christmas at Etten in Holland.	The impressionists organize an auction at the Hôtel Drouot on March 24. Mallarmé publishes *L'après-midi d'un faune* illustrated by Manet.
1876	On April 1 he resigns from Goupil and leaves for Ramsgate in England. In December he returns to Etten but, alarmed by his physical and emotional condition, his parents convince him not to return to England.	
1878	At the end of August he goes to study at a mission school at Laeken near Brussels. At the end of the trimester he is deemed unsuitable for the work involved.	Exposition Universelle in Paris. Duret publishes *Les impressionistes* and Cézanne works in Aix-en-Provence and then Estaque.

Life of Vincent van Gogh	Historical and Artistic Events
1879 He is appointed lay evangelist for six months at Wasmes in the mining region close to Mons in Belgium but his position is not renewed. He begins to draw and goes to Carrières where Jules Breton, a painter he has admired for some time, lives.	Fourth impressionist exhibition. Zola reviews the Salon for a magazine and criticizes the impressionists for "insufficient technique."
1880 In October he leaves for Brussels and becomes friends with the painter Anton van Rappard. From Paris Theo begins to send him a small monthly allowance.	Dostoevsky publishes *The Brothers Karamazov*. Fifth impressionist exhibition.
1881 In The Hague he takes lessons in drawing and painting from Anton Mauve. He begins to collect French and English woodcuts and makes his first oil paintings of still lifes and watercolors of models from life.	Tunisia is made a French protectorate. Sixth impressionist exhibition and the French State renounces its control of the Salon, leading to the formation of the Société des Artistes Français. Manet is awarded the Légion d'Honneur.
1884 He moves to Brabant and paints rural life.	The Société des Vingt (Les XX) is founded in Brussels and in Paris the Groupe des Artistes Indépendants. A large retrospective of the work of Manet is held at the École des Beaux-Arts with an introduction to the catalogue by Zola. Seurat works on the painting *La Grande Jatte* and Huysmans publishes *À rebours*.
1885 In March his father dies. At the end of November he goes to Antwerp where he studies the works of Rubens and begins to collect Japanese prints.	Retrospective of Delacroix at the École des Beaux-Arts. Pissarro and Sisley meet Theo van Gogh.
1886 In early March he goes to stay with his brother in Paris. He takes lessons in the studio of the painter Cormon where he meets Toulouse-Lautrec and Bernard. He also meets Monet, Sisley, Pissarro, Degas, Renoir, Seurat, and Signac.	Seventh and last impressionist exhibition. Monet and Renoir refuse to take part due to the presence of Seurat, who presents his *La Grande Jatte*. Gauguin goes to Pont-Aven, Zola publishes *L'oeuvre*, Fénéon *Les impressionistes en 1886* and Moréas the symbolist manifesto in the *Figaro Litteraire*.

Life of Vincent van Gogh	Historical and Artistic Events
1887 In winter he makes friends with Gauguin. He organizes an exhibition with Bernard, Anquetin, and Toulouse-Lautrec. The group refers to itself as *Peintres du petit boulevard* in contrast to the *Peintres du grand boulevard* who exhibit in Theo's gallery: Monet, Sisley, Degas, Pissarro, and Seurat.	Formation of the Indochinese Union, which brings together the French colonies in Southeast Asia. Gauguin visits Martinique where he lives with Laval.
1888 In February Vincent moves to Arles where he rents the Yellow House and paints assiduously. From October to December he shares the house with Gauguin. On December 23, according to Gauguin's account, Vincent tries to strike him with a razor; frightened, Gauguin spends the night in a hotel. That same night Vincent cuts off a piece of his left ear.	Émile Bernard is in Pont-Aven where he visits Gauguin. In Paris a solo show is put on of Gauguin's works in Theo van Gogh's gallery.
1889 In May he decides to enter a mental hospital but still paints intensely. Two of his paintings are exhibited at the Salon des Indépendants. In November he sends six canvases to the eighth exhibition of Les XX.	Opening of the International Fair in Paris. The art section has an exhibition of one hundred years of French art that includes Manet, Monet, Pissarro, and Cézanne.
1890 He moves to Auvers-sur-Oise where Dr. Gachet takes him into his house. On July 27 Vincent shoots himself in the chest in the middle of a wheat field and dies two days later.	First celebration of May 1. In *Définition du néo-traditionnisme* Denis publishes the principles of the art of Gauguin, who has by now returned to Paris.
1891 Following the death of his brother, Theo falls ill and dies on January 25. In 1914 his remains are transferred to the cemetery in Auvers and placed next to those of Vincent.	Gauguin sets sail for Tahiti on April 4. Seurat and Meissonier die.

Geographical Locations of the Paintings
(in public collections)

Italy

Breton Women
Watercolor, 47.5 x 62 cm
Milan, Civica Galleria d'Arte
Moderna
1888

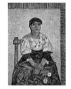
L'Arlésienne (Madame Ginoux)
Oil on canvas, 60 x 50 cm
Rome, Galleria Nazionale
d'Arte Moderna
1890

France

The Restaurant de la Sirène at Asnières
Oil on canvas, 54 x 65 cm
Paris, Musée d'Orsay
1887

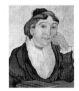
Italian Woman (Agostina Segatori?)
Oil on canvas, 81 x 60 cm
Paris, Musée d'Orsay
1887

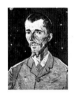
Portrait of Eugène Boch
Oil on canvas, 60 x 45 cm
Paris, Musée d'Orsay
1888

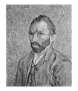
Self-Portrait
Oil on canvas, 65 x 54 cm
Paris, Musée d'Orsay
1889

Thatched Cottages in Cordeville
Oil on canvas, 72 x 91 cm
Paris, Musée d'Orsay
1890

Marguerite Gachet in the Garden
Oil on canvas, 46 x 55 cm
Paris, Musée d'Orsay
1890

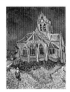
The Church at Auvers
Oil on canvas, 94 x 74 cm
Paris, Musée d'Orsay
1890

Germany	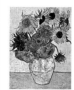	Twelve Sunflowers in a Vase Oil on canvas, 91 x 72 cm Munich, Neue Pinakothek 1888	
Great Britain	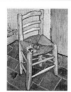	Vincent's Chair Oil on canvas, 93 x 73.5 cm London, National Gallery 1888	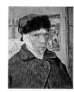 Self-Portrait with Bandaged Ear Oil on canvas, 60 x 49 cm London, Courtauld Institute Gallery 1889
Holland	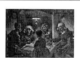	The Potato Eaters Oil on canvas, 82.5 x 114 cm Amsterdam, Van Gogh Museum 1885	Still Life with Bible Oil on canvas, 65 x 78 cm Amsterdam, Van Gogh Museum 1885
		Japonaiserie: Oiran Oil on canvas, 105.5 x 60.5 cm Amsterdam, Van Gogh Museum 1887	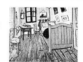 Vincent's Bedroom i Oil on canvas, 72 x 90 cm Amsterdam, Van Gogh Museum 1888
		Gauguin's Armchair Oil on canvas, 90.5 x 72.5 cm Amsterdam, Van Gogh Museum 1888	The Yellow House Oil on canvas, 76 x 94 cm Amsterdam, Van Gogh Museum 1888

Holland

Wheat Field with Crows
Oil on canvas, 50.5 x 103 cm
Amsterdam, Van Gogh
Museum
1890

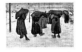

*Sprig of Flowering Almond
Blossom in a Glass*
Oil on canvas, 24 x 19 cm
Amsterdam, Van Gogh
Museum
1888

*Women Carrying Sacks
of Coal*
Watercolor, 32 x 50 cm
Otterlo, Kröller-Müller
Museum
1882

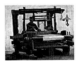

Weaver, Seen from the Front
Oil on canvas, 64 x 80 cm
Otterlo, Kröller-Müller
Museum
1884

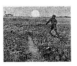

Willows at Sunset
Oil on canvas applied on
cardboard, 31.5 x 34.5 cm
Otterlo, Kröller-Müller
Museum
1888

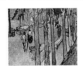

Café Terrace at Night
Oil on canvas, 81 x 65.5 cm
Otterlo, Kröller-Müller
Museum
1888

The Sower
Oil on canvas, 64 x 80.5 cm
Otterlo, Kröller-Müller
Museum
1888

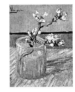

*Les Alyscamps, Falling
Autumn Leaves*
Oil on canvas, 73 x 92 cm
Otterlo, Kröller-Müller
Museum
1888

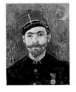

*Portrait of Milliet, Second
Lieutenant of the Zouaves*
Oil on canvas, 60 x 49 cm
Otterlo, Kröller-Müller
Museum
1888

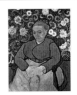

La Berceuse
Oil on canvas, 92 x 73 cm
Otterlo, Kröller-Müller
Museum
1889

Holland

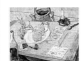

Still Life with Drawing Board,
Pipe, Onions and Sealing Wax
Oil on canvas, 50 x 64 cm
Otterlo, Kröller-Müller Museum
1889

Russia

Portrait of Doctor Felix Rey
Oil on canvas, 63 x 53 cm
Moscow, The Pushkin State
Museum of Fine Arts
1889

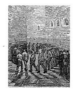

Prisoner's Round
(after Gustave Doré)
Oil on canvas, 80 x 64 cm
Moscow, Pushkin Museum
1890

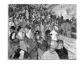

Spectactors in the Arena
at Arles
Oil on canvas, 73 x 92 cm
St Petersburg, The State
Hermitage Museum
1888

Lilacs
Oil on canvas, 73 x 92 cm
St. Petersburg, The State
Hermitage Musem
1889

Spain

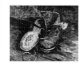

Landscape at Dusk
Canvas on cardboard,
35 x 43 cm
Madrid, Museo Thyssen-
Bornemisza
1885

United States

A Pair of Shoes
Oil on canvas, 34 x 41.5 cm
Baltimore, The Baltimore
Museum of Art
1887

Portrait of the Postman
Joseph Roulin
Oil on canvas, 81.2 x 65.3 cm
Boston, Museum of Fine Arts
1888

United States

Irises
Oil on canvas, 71 x 93 cm
Los Angeles, The J. Paul
Getty Museum
1889

The Night Café
Oil on canvas, 70 x 89 cm
New Haven, Yale University
Art Gallery
1888

Sunflowers
Oil on canvas, 43.2 x 61 cm
New York, The Metropolitan
Museum of Art
1887

*L'Arlésienne: Madame Joseph-
Michel Ginoux
(Marie Julien, 1848–1911)*
Oil on canvas, 91.4 x 73.7 cm
New York, The Metropolitan
Museum of Art
1888 or 1889

The Starry Night
Oil on canvas, 73.7 x 92.1 cm
New York, The Museum of
Modern Art,
Lillie P. Bliss Bequest.
Digital Image © 2002 New York,
The Museum of Modern Art
1889

Irises
Oil on canvas, 92 x 73.5 cm
New York, The Metropolitan
Museum of Art
1890

La Mousmé
Oil on canvas, 74 x 60 cm
Washington, D.C., National
Gallery of Art
1888

Switzerland

*Marguerite Gachet
at the Piano*
Oil on canvas, 102.6 x 50 cm
Basel, Kunstmuseum
1890

Vase with Hollyhocks
Oil on canvas, 91 x 50.5 cm
Zurich, Kunsthaus
1886

Cuesmes, 24 Sept. 1880

Dear Theo,

Your letter has done me good and I thank you for having written to me in the way you have.

The roll with a new selection of etchings & various prints has just arrived. First and foremost the masterly etching, Le buisson, by Daubigny / Ruysdael. Well! I propose to make two drawings, in sepia or something else, one after that etching, the other after Le four dans les Landes by Th. Rousseau. Indeed, I have already done a sepia of the latter, but if you compare it with Daubigny's etching you will see that it contrasts feebly, although considered on its own the sepia may betray some tone & sentiment. I shall have to return to it & tackle it again.

I am still working on Bargue's Cours de dessin & intend to finish it before I go on to anything else, for both my hand and my mind are growing daily more supple & strong as a result, & I cannot thank Mr Tersteeg enough for having been so kind as to lend it to me. The models are outstanding. Meanwhile I am reading one book on anatomy & another on perspective, which Mr Tersteeg also sent me. These studies are demanding & sometimes the books are extremely tedious, but I think all the same that it's doing me good to study them.

So you see that I am working away hard, though for the moment it is not yielding particularly gratifying results. But I have every hope that these thorns will bear white blooms in due course & that these apparently fruitless struggles are nothing but labour pains. First the pain, then the joy.

You mention Lessore. I think I remember some very elegant watercolour landscapes by him in a blond tone, worked with an apparent ease & a light touch, yet with accuracy and distinction, & a somewhat decorative effect (that is not meant badly, but on the contrary in a favourable sense). So I know a little about his work & you mention someone not entirely unknown to me.

I admire the portrait of Victor Hugo. It is done very conscientiously with the evident intention of portraying the truth without straining after effect.

That is precisely what makes it so effective.

Last winter I poured over some of Hugo's works, Le dernier jour d'un condamné & an excellent book on Shakespeare. I first started studying this writer long ago. He is just as splendid as Rembrandt. Shakespeare is to Charles Dickens or V. Hugo what Ruysdael is to Daubigny, & Rembrandt to Millet.

What you say in your letter about Barbizon is perfectly true & I can tell you one or two things that will make it clear how much I share your view. I haven't been to Barbizon, but though I haven't been there, I did go to Courrières last winter. I went on a walking tour in the Pas-de-Calais, not the English Channel but the department, or province. I had gone on this trip in the hope of perhaps finding some sort of work there, if possible—I would have accepted anything—but in fact I set out a bit reluctantly, though I can't say exactly why. But I had told myself, you must see Courrières. I had just 10 francs in my pocket and because I had started out by taking the train, that was soon gone, & as I was on the road for a week, it was a rather gruelling trip. Anyway, I saw Courrières & the outside of M. Jules Breton's studio. The outside of the studio was a bit of a disappointment, seeing that it is a brand-new studio, recently built of brick, of a Methodist regularity, with an inhospitable, stone-cold & forbidding aspect, just like C. M.'s Jovinda, which, between ourselves, I am none too keen on either, for the same reason. If I could have seen the inside, I am quite certain that I should have given no further thought to the outside, but there you are, I could not see the inside because I dared not introduce myself and go in. Elsewhere in Courrières I looked for traces of Jules Breton or any other artist. All I was able to find was a portrait of him at a photographer's & a copy of Titian's Entombment in a corner of the old church which looked very beautiful to me in the darkness & masterly in tone. Was it by him? I don't know because I was unable to make out any signature.

But of any living artist, no trace, just a café called the Café des Beaux Arts, also of new, inhospitable, stone-cold, repulsive brick—the café was decorated with a kind of fresco or mural depicting episodes from the life of that illustrious knight, Don Quixote.

To tell the truth, the frescos seemed to me rather poor consolation and fairly mediocre at the time. I don't know who did them.

But anyway I did see the country around Courrières then, the haystacks, the brown farmland or the marled earth, almost coffee-colored (with whitish spots where the marl shows through), which seems somewhat unusual to people like us who are used to a blackish soil. And the French sky looked to me much finer & brighter than the smoky & foggy sky of the Borinage. What's more, there were farms & barns that, God be praised, still retained their mossy thatched roofs. I also saw the flocks of crows made famous by Daubigny & Millet. Not to mention, as I ought to have done in the first place, the characteristic & picturesque figures of all manner of workmen, diggers, woodcutters, a farmhand driving his wagon & a silhouette of a woman with a white cap. Even in Courrières there was still a coal mine or pit, I saw the day shift come up at nightfall, but there were no women worker's in men's clothes as in the Borinage, just the miners looking tired & careworn, black with coal dust, dressed in ragged miners' clothes, one of them in an old army cape.

Although this trip nearly killed me & though I came back spent with fatigue, with crippled feet & in a more or less depressed state of mind, I do not regret it, because I saw some interesting things and the terrible ordeals of suffering are what teach you to look at things through different eyes.

I earned a few crusts here and there en route in exchange for a picture or a drawing or two I had in my bag. But when my ten francs ran out I tried to bivouac in the open the last 3 nights, once in an abandoned carriage which was completely white with hoarfrost the next morning,

not the best accommodation, once in a pile of faggots, and once, & that was a slight improvement, in a haystack that had been opened up, where I succeeded in making myself a slightly more comfortable little hideaway, though the drizzle did not exactly add to my enjoyment.

Well, even in these depths of misery I felt my energy revive & said to myself, I shall get over it somehow, I shall set to work with my pencil, which I had cast aside in my deep dejection, & I shall draw again, & ever since I have had the feeling that everything has changed for me, & now I am in my stride & my pencil has become slightly more willing & seems to be getting more so by the day. My over-long & over-intense misery had discouraged me so much that I was unable to do anything.

I saw something else during the trip—the weavers' villages. The miners & the weavers still form a race somehow apart from other workers & artisans and I have much fellow-feeling for them & should consider myself fortunate if I could draw them one day, for then these as yet unknown, or virtually unknown, types would be brought out into the light of day.

The man from the depths, from the abyss, 'de profundis', that is the miner. The other with the faraway look, almost daydreaming, almost a sleepwalker, that is the weaver. I have been living among them now for nearly 2 years & have learned a little of their special character, in particular that of the miners. And increasingly I find something touching & even pathetic in these poor, humble workers, the lowest of the low in a manner of speaking, and the most despised, who, owing to a possibly widely held but quite baseless and inaccurate presumption, are usually considered a race of knaves & scoundrels. Knaves, drunkards & scoundrels may be found here, of course, just as elsewhere, but the real type is nothing at all like that.

You refer vaguely in your letter to my coming sooner or later to Paris or its environs, if it were possible & if I wanted to. It is of course my eager & fervent wish to go either to Paris or to Barbizon, or somewhere else, but how I can, when I do not earn a cent and when, though I work hard, it will still be some time before I reach the point at which I can give any thought to something like going to Paris. For honestly, to be able to work properly I need at least a hundred francs a month. You can certainly live on less, but then you really are hard up, much too hard up in fact!

Poverty stops the best minds in their tracks, the old Palizzi saying goes, which has some truth in it & is entirely true if you understand its real meaning and import. For the moment I do not see how it could be feasible, and the best thing is for me to stay here & work as hard as I can, & after all, it is cheaper to live here.

At the same time I must tell you that I cannot remain very much longer in the little room where I live now. It is very small indeed, and then there are two beds as well, the children's & my own. And now that I am working on Bargue's fairly large sheets I cannot tell you how difficult it is. I don't want to upset these people's domestic arrangements. They have already told me that I couldn't have the other room in the house under any circumstances, not even if I paid more, for the woman needs it for her washing, which in a miner's house has to be done almost every day. In short, I should like to rent a small workman's cottage. It costs about 9 francs a month.

I cannot tell you (though fresh problems arise & will continue to arise every day), I cannot tell you how happy I am that I have taken up drawing again. I had been thinking about it for a long time, but always considered it impossible & beyond my abilities. But now, though I continue to be conscious of my failings & of my depressing dependence on a great many things, now I have recovered my peace of mind & my energy increases by the day.

As far as coming to Paris is concerned, it would be of particular advantage to me if we could manage to establish contact with some good & able artist, but to be quite blunt about it, it might only be a repetition on a large scale of my trip to Courrières, where I hoped to come

across a living example of the species Artist and found none. For me the object is to learn to draw well, to gain control of my pencil, my charcoal or my brush. Once I have achieved that I shall be able to do good work almost anywhere and the Borinage is as picturesque as old Venice, as Arabia, as Brittany, Normandy, Picardy or Brie.

Should my work be no good, it will be my own fault. But in Barbizon, you most certainly have a better chance than elsewhere of meeting a good artist who would be as an angel sent by God, should such a happy meeting take place. I say this in all seriousness and without exaggeration. So if, sometime or other, you should see the means & the opportunity, please think of me. Meanwhile I'll stay here quietly in some small workman's cottage and work as hard as I can.

You mentioned Meyron again. What you say about him is quite true. I know his etchings slightly. If you want to see something curious, then place one of his meticulous & powerful sketches next to a print by Viollet-le-Duc or anyone else engaged in architecture. If you do, then you will see Meyron in his true light, thanks to the other etching which will serve, whether you like it or not, as a foil or contrast. Right, so what do you see? This. Even when he draws bricks, granite, iron bars or the railing of a bridge, Meyron puts into his etchings something of the human soul, moved by I know not what inner sorrow. I have seen V. Hugo's drawings of Gothic buildings. Well, though they lacked Meyron's powerful and masterly technique, they had something of the same sentiment. What sort of sentiment is that? It is akin to what Albrecht Dürer expressed in his *Melancholia*, and James Tissot and M. Maris (different though these two may be) in our own day. A discerning critic one rightly said of James Tissot, 'He is a troubled soul.' However this may be, there is something of the human soul in his work and that is why he is great, immense, infinite. But place Viollet-le-Duc alongside and he is stone, while the other, that is, Meyron, is Spirit.

Meyron is said to have had so much love

that, just like Sydney Carton, he loved even the stones of certain places. But in Millet, in Jules Breton, in Jozef Israëls, the precious pearl, the human soul, is even more in evidence and better expressed, in a noble, worthier, & if you will allow me, more evangelical tone.

But to return to Meyron, in my view he also has a distant kinship with Jongkind & perhaps with Seymour Hayden, since at times these two artists have been extremely good.

Just wait, and perhaps you'll see that I too am a workman. Though I cannot predict what I shall be able to do, I hope to make a few sketches with perhaps something human in them, but first I must do the Bargue drawings and other more or less difficult things. Narrow is the way & strait the gate & there are only a few who find it.

Thanking you for your kindness, especially for Le buisson, I shake your hand,

Vincent

I have now taken your whole collection, but you will get it back later and in addition I've got some very fine things for your collection of wood engravings, which I hope you will continue in the two volumes of the Musée Universal which I am keeping for you.

[21 July 1882]
Dear brother,
It is already late, but I felt like writing to you again anyway. You are not here—but I need you & sometimes feel we are not far away from each other.

Today I promised myself something, that is to treat my indisposition, or rather what remains of it, as if it didn't exist. Enough time has been lost, work must go on. So, well or not well, I am going back to drawing regularly from morning till night. I don't want anybody to be able to say to me again, 'Oh, but those are only old drawings.'

I drew a study today of the child's little cradle with some touches of colour in it. I am also at work

on one like those meadows I sent you recently.

My hands have become a little too white for my liking, but that's too bad. I'm going to go back outdoors again, a possible relapse matters less to me than staying away from work any longer.

Art is jealous, she doesn't like taking second place to an indisposition. Hence I shall humour her. So you will, I hope, be receiving a few more reasonably acceptable things shortly.

People like me really should not be ill. I would like to make it perfectly clear to you how I look at art. To get to the essence of things one has to work long & hard.

What I want & have as my aim is infernally difficult to achieve, and yet I don't think I am raising my sights too high. I want to do some drawings that will touch some people.

Sorrow is a small beginning—perhaps such little landscapes as the Meerdervoort Avenue, the Rijswijk Meadows, and the Dab Drying Shed are also a small beginning. There is at least something straight from my own heart in them. What I want to express, in both figure and landscape, isn't anything sentimental or melancholy, but deep anguish. In short, I want to get to the point where people say of my work: that man feels deeply, that man feels keenly. In spite of my so-called hoarseness—do you understand?—perhaps for that very reason. It seems pretentious to talk like that now, but that is the reason why I want to put all my energies into it.

What I am in the eyes of most people—a nonentity, an eccentric, or an unpleasant person— somebody who has no position in society and never will have, in short, the lowest of the low. All right, then—even if that were absolutely true, then I should one day like to show by my work what such an eccentric, such a nobody has in his heart.

That is my ambition, based less on resentment than on love *malgré tout*,[1] based more on a feeling of serenity than on passion.

Though I am often in the depths of misery, there is still calmness, pure harmony and music inside me. I see paintings or drawings in the poorest cottages, in the dirtiest corners. And my mind is driven towards these things with an irresistible momentum.

Other things increasingly lose their hold on me, and the more they do so the more quickly my eye lights on the picturesque. Art demands dogged work, work in spite of everything and continuous observation. By dogged, I mean in the first place incessant labour, but also not abandoning one's views upon the say-so of this person or that.

I am not without hope, brother, that in a few years' time, or perhaps even now, little by little you will be seeing things I have done that will give you some satisfaction after all your sacrifices.

I have had singularly little discourse with painters lately. I haven't been the worse for it. It isn't the language of nature that one should heed. I can understand better now than I could a good six months ago why Mauve said: don't talk to me about Dupré, I'd rather you talked to me about that ditch, or something of the sort. That may sound a bit strong, and yet it is absolutely right. The feeling for things themselves, for reality, is of greater importance than the feeling for painting; anyway it is more productive and more inspiring.

Because I now have such a broad, such an expansive feeling for art and for life itself, of which art is the essence, it sounds so shrill and false when people like Tersteeg do nothing but harry one.

For my own part, I find that many modern pictures have a peculiar charm for which the old ones lack. To me, one of the highest and noblest expressions of art will always be that of the English, for instance Millais and Herkomer and Frank Holl. What I would say with respect to the difference between old & present-day art is— perhaps the modern artists are deeper thinkers.

There is a great difference in sentiment between, for instance, Chill October by Millais and Bleaching Ground at Overveen by Ruysdael. And equally between Irish Emigrants by Holl and the women reading from the Bible by Rembrandt. Rembrandt & Ruysdael are sublime, for us as well as for their contemporaries, but

there is something in the moderns that seems to us more personal and intimate.

It is the same with Swain's woodcuts & those of the old German masters.

And so it was a mistake when the modern painters thought it all the rage to imitate the old ones a few years ago. That's why I think old Millet is so right to say, 'Il me semble absurde que les hommes veuillent paraître autre chose que ce qu'ils sont.'[2] That may sound trite, and yet it is unfathomably deep as the ocean, and personally I am all for taking it to heart.

I just wanted to tell you that I am going to get back to working regularly again, and must do so *quand même*[3]—and I'd just like to add that I look forward so much to a letter—and for the rest I bid you good-night. Goodbye, with a handshake,

Ever yours,
Vincent

Please remember the thick Ingres if you can, enclosed is another sample. I still have a supply of the thin kind. I can do watercolour washes on the thick Ingres, but on the sans fin,[4] for instance, it always goes blurry, which isn't entirely my fault.

I hope that by keeping hard at it I shall draw the little cradle another hundred times, besides what I did today.

[1] In spite of everything.

[2] It seems absurd to me that people want to seem other than they are.

[3] At that.

[4] Endless. Van Gogh was probably referring to 'paper on a roll' of a certain standard thickness.

postscript
[c. 4–8 August 1883]
[…] For no particular reason, I cannot help adding a thought that often occurs to me. Not only did I start drawing relatively late in life, but it may well be that I shall not be able to count on many more years of life either.

I think about it dispassionately—as if making calculations for an estimate or a specification—then it is in the nature of things that I cannot possibly known anything definitely about it.

But by comparison with various people with whose lives one may be familiar or by comparison with some with whom one is supposed to have some things in common, one can draw certain conclusions that are not completely without foundation.

So, as to the time I still have ahead of me for work, I think I might safely presume that my body will hold up for a certain number of years quand *bien même*[1]—a certain number between 6 and 10, say. (I can assume this the more safely as there is for the time being no immediate quand bien même.)

This is the period on which I count firmly. For the rest, would be speculating far too wildly for me to dare make any definite pronouncements about myself, seeing that it depends precisely on those first, say, 10 years as to whether or not there will be anything after that time.

If one wears oneself out during these years then one won't live beyond 40. If one conserves enough strength to withstand the sort of shocks that tend to befall one, and manages to deal with various more or less complicated physical problems, then by the age of 40 to 50 one is back on a new relatively normal course.

But such calculations are not relevant at present. Instead, as I started to say, one should plan for a period of between 5 and 10 years. I do not intend to spare myself, to avoid emotions or difficulties—it makes comparatively little difference to me whether I go on living for a shorter or longer time—besides I am not competent to manage my constitution the way, say, the physician is able to. And so I go on like an ignoramus, one who knows just one thing: within a few years I must have done a certain amount of work—I don't need to rush, for there is no point in that, but I must carry on working in complete calm and serenity, as regularly and with as much concentration as possible, as much to the point as

possible. The world concerns me only in so far as I owe it a certain debt and duty, so to speak, because I have walked this earth for 30 years, and out of gratitude would like to leave some memento in the form of drawings and paintings—not made to please this school or that, but to express a genuine human feeling. So that work is my aim—and when one concentrates on this notion, everything one does is simplified, in that it isn't muddled but has a single objective. At present the work is going slowly—one reason more not to lose any time.

Guillaume Regamey was, I think, someone who left behind no particular reputation (you know that there are two Regameys, F. Regamy paints Japanese people and is his brother), but is nevertheless a personality for whom I have great respect. He died at the age of 38, and one period of his life lasting for 6 or 7 years was almost exclusively devoted to drawings with a highly distinctive style, done while he worked under some physical handicap. He is one of many—a very good one among many good ones.

I don't mention him to compare myself with him, I am not as good as he was, but to site a specific example of self-control and willpower, sustained by one inspiring idea, which in difficult circumstances nevertheless showed him how to do good work with utter serenity.

That is how I regard myself, as having to accomplish something in a few years full of heart and love, and to do it with a will. Should I live longer, *tant mieux*,[2] but I put that out of my mind. Something must be accomplished in those few years, this thought guides all my plans. You will understand better now why I have a yearning to press on—and at the same time some determination to use simple means. And perhaps you will also be able to understand that as far as I am concerned I do not consider my studies in isolation but always think of my work as a whole.

[1] In spite of everything.

[2] So much the better.

[c. 30 April 1885]

My dear Theo,

My warmest good wishes for health & peace of mind on your birthday. I should have liked to send the painting of the Potato Eaters for this day, but although it's coming along well, it isn't quite finished yet.

Though the actual painting will have been completed in a comparatively short time, and largely from memory, it has taken a whole winter of painting studies of heads & hands.

And as for the few days in which I have painted it now—it's been a tremendous battle, but one for which I was filled with great enthusiasm. Even though at times I was afraid it would never come off. But painting, too, is *agir-créer*.[1]

When weavers weave that cloth which I think they call cheviot, or those curious multicoloured Scottish tartan fabrics, then they try, as you know, to get strange broken colours and greys into the cheviot—and to get the most vivid colours to balance each other in the multicoloured chequered cloth—so instead of the fabric being a jumble, the effet produit[2] of the pattern looks harmonious from a distance.

A grey woven from red, blue, yellow, off-white & black threads—a blue broken by a green and an orange, red or yellow thread—are quite unlike plain colours, that is, they are more vibrant and primary colours seem hard, cold and lifeless beside them. Yet the weaver, or rather the designer, of the pattern or the colour combination does not always find it easy to make an exact estimate of the number of threads and their direction—no more than it is easy to weave brush strokes into a harmonious whole.

If you could see the first painted studies I did on my arrival here in Nuenen side by side with the canvas I am doing now, I think you would agree that things are livening up a bit as far as colour is concerned.

I feel certain that you too will get involved in the question of colour analysis one day. For as an art connoisseur and critic, it seems to me, one

must also be sure of one's ground and have firm convictions—for one's own pleasure at least, and in order to substantiate one's opinion. And one should also be able to explain it in a few words to others who sometimes turn to someone like yourself for information when they want to know a little more about art.

But now I have something to say about Portier. Of course I am not wholly indifferent to his private opinion and I also appreciate his saying that he does not take back anything of what he has said. Nor do I mind that he apparently failed to hang these first studies. But—if he wants me to send him a painting intended for him, then he can only have it on condition that he shows it.

As for *The Potato Eaters*—it is a painting that will do well in gold—of that I am certain. But it would do just as well on a wall papered in a deep shade of ripe corn. However, it simply mustn't be seen without being set off in this way. It will not appear to full advantage against a dark background and especially not against a dull background. And that is because it is a glimpse into a very grey interior. In real life it is also set in a gold frame, as it were, because the hearth and the light from the fire on the white walls would be nearer the spectator—they are situated outside the painting, but in its natural state the whole thing is projected backwards.

Once again, it must be set off by putting something coloured a deep gold or copper round it. Please bear that in mind if you want to see it as it should be seen. Associating it with a gold tone lends brightness to areas where you would least expect it, and at the same time does away with the marbled aspect it assumes if it is unfortunately placed against a dull or a black background. The shadows are painted with blue and the gold colour sets this off.

Yesterday, I took it to a friend of mine in Eindhoven who is doing some painting. In about 3 days' time I'll go back over there and give it some egg-white and finish off a few details.

This man, who is trying very hard himself to learn how to paint and to handle colour, was particularly taken with it. He had already seen the study on which I had based the lithograph and said that he would never have believed I could improve the colour and the drawing to such an extent. As he, too, paints from the model, he's well aware of what there is to a peasant's head or fist, and as for the hands, he said that he now had a quite different understanding of how to do them.

The point is that I've tried to bring out the idea that these people eating potatoes by the light of their lamp have dug the earth with the self-same hands they are now putting into the dish, and it thus suggests manual labour and—a meal honestly earned. I wanted to convey a picture of a way of life quite different from ours, from that of civilized people. So the last thing I would want is for people to admire or approve of it without knowing why.

I've held the threads of this fabric in my hands all winter long and searched for the definitive pattern—and although it is now a fabric of rough and coarse appearance, the threads have none the less been chosen with care and according to certain rules. And it might just turn out to be a genuine peasant painting. I know that it is. But anyone who prefers to have his peasants looking namby-pamby had best suit himself. Personally, I am convinced that in the long run one gets better results from painting them in all their coarseness than from introducing a conventional sweetness.

A peasant girl, in her patched and dusty blue skirt & bodice which have acquired the most delicate shades from the weather, wind and sun, is better looking—in my opinion—than a lady. But if she dons a lady's clothes, then her authenticity is gone. A peasant in his fustian clothes out in the fields [is] better looking than when he goes to church on Sundays in a kind of gentleman's coat.

And similarly, in my opinion, it would be wrong to give a painting of peasant life a conventional polish. If a peasant painting smells of bacon, smoke, potato steam, fine—that's not unhealthy—if a stable reeks of manure—all right, that's what a stable is all about—if a field has the smell of ripe

corn or potatoes or of guano & manure—that's properly healthy, especially for city dwellers. Such pictures might prove helpful to them. But a painting of peasant life should not be perfumed.

I am eager to know whether you will find something in it to please you—I hope so.

I'm glad that just as Mr Portier has said that he'll handle my work, I've got something more important for him than studies. As for Durand-Ruel—though he didn't consider the drawings worth bothering with, do show him this painting. Let him think it ugly, I don't mind—But let him have a look at it all the same, let people see that we put some effort into our endeavours. No doubt you'll hear 'quelle croûte!'[3] Be prepared for that, as I am prepared myself. Yet we must go on providing something genuine and honest.

Painting peasant life is a serious business, and I for one would blame myself if I didn't try to make pictures that give rise to serious reflection in those who think seriously about art and life.

Millet, De Groux, so many others, have set an example of character by turning a deaf ear to such taunts as 'sale, grossier, boueux, puant',[4] & c., & c., so it would be a disgrace should one so much as waver. No, one must paint peasants as if one were one of them, as if one felt and thought as they do. Being unable to help what one actually is. I very often think that peasants are a world apart, and in many respects one so much better than the civilized world. Not in all respects, for what do they know of art and many other things?

I still have a few smaller studies—but you will appreciate that I'm being kept so busy by the larger one that I've been able to do little else. As soon as it is completely finished and dry, I shall forward you the canvas in a small packing case, adding a few smaller items. I think it would be as well not to delay the dispatch too long, which is why I'll make haste with it. The second lithograph of it will probably have to be abandoned in that case, though I realize that Mr Portier, for instance, must have his opinion endorsed if we are to count on him once and for all as a friend. It is my sincere hope that we may.

I have been so absorbed in the painting that I almost forgot that I am moving house, something that has to be attended to as well. My worries won't be any the less, but the lives of all painters in this genre have been so full of cares that I shouldn't want to have things any easier than they did. And since they managed to get their paintings done anyway, I, too, may be held back by material difficulties, but not destroyed or undermined by them. So there you are.

I believe that *The Potato Eaters* will turn out well—as you know, the last few days are always tricky with a painting because before it's completely dry one can't use a large brush without running a real risk of spoiling it. And changes must be made very coolly and calmly with a small brush. That's why I took it to my friend and asked him to make certain I didn't spoil it, and why I'll be going to his place to apply those finishing touches.

You'll certainly see that it has originality. Regards, I'm sorry it wasn't ready for today—best wishes once again for your health and peace of mind, believe me, with a handshake,

Ever yours,
Vincent

I'm still working on some smaller studies that will go off at the same time. Did you ever send that copy of the Salon issue?

From *The Letters of Vincent van Gogh.* Selected and edited by Ronald de Leeuw. Translated by Arnold Pomerans. Published by Penguin Books, London 1996. Reproduced by permission of Penguin Books Ltd.

[1] Acting-creating.

[2] Overall effect.

[3] What a daub!

[4] Nasty, crude, filthy, stinking.

Concise Bibliography

Dorn, Roland, George S. Keyes, Joseph J. Rishel, Katherine Sachs, George T.M. Shackelford, Lauren Soth, and Judy Sund. *Van Gogh Face to Face: The Portraits.* New York: Thames & Hudson, 2000.

Druick, Douglas W., and Peter Kort Zegers. *Van Gogh and Gauguin: The Studio of the South.* London: Thames & Hudson, 2001.

Heinich, Nathalie. *The Glory of van Gogh: An Anthropology of Admiration.* Trans. Paul Leduc Browne. Chicago: University of Chicago Press, 1997.

Kendall, Richard. *Van Gogh's Van Goghs: Masterpieces from the Van Gogh Museum, Amsterdam.* New York: Harry N. Abrams, 1998.

Leeuw, Ronald de, ed. and Arnold Pomerans, trans. *The Letters of Vincent van Gogh.* London: Penguin Books, 1996.

Rewald, John. *Post-Impressionism from Van Gogh to Gauguin.* New York: Museum of Modern Art, 1979.

Saltzman, Cynthia. *Portrait of Dr. Gachet: The Story of a van Gogh Masterpiece, Money, Politics, Collectors, Greed, and Loss.* New York: Viking, 1998.

Silverman, Debora. *Van Gogh and Gauguin: The Search for Sacred Art.* New York: Farrar, Straus and Giroux, 2000.

Stolwijk, Chris, Sjraar van Heugten, Leo Jansen, Andreas Blühm, Nienke Bakker, Roelie Zwikker, Wouter van der Veen, Joan Greer, Evert van Uitert, Hans Luijten, Cornelia Homburg. *Vincent's Choice: Van Gogh's Musée Imaginaire.* London: Thames & Hudson, 2003.